CHURCHES OF GLOUCESTERSHIRE

NICOLA COLDSTREAM

AMBERLEY

To the clergy and churchwardens of Gloucestershire

This edition first published 2024

Amberley Publishing
The Hill, Stroud
Gloucestershire GL5 4EP

www.amberley-books.com

British Library Cataloguing in Publication Data.
A catalogue record for this book is available from the British Library.

ISBN 978 1 3981 1144 8 (print)
ISBN 978 1 3981 1145 5 (ebook)

Typesetting by SJmagic DESIGN SERVICES, India.
Printed in Great Britain.

CONTENTS

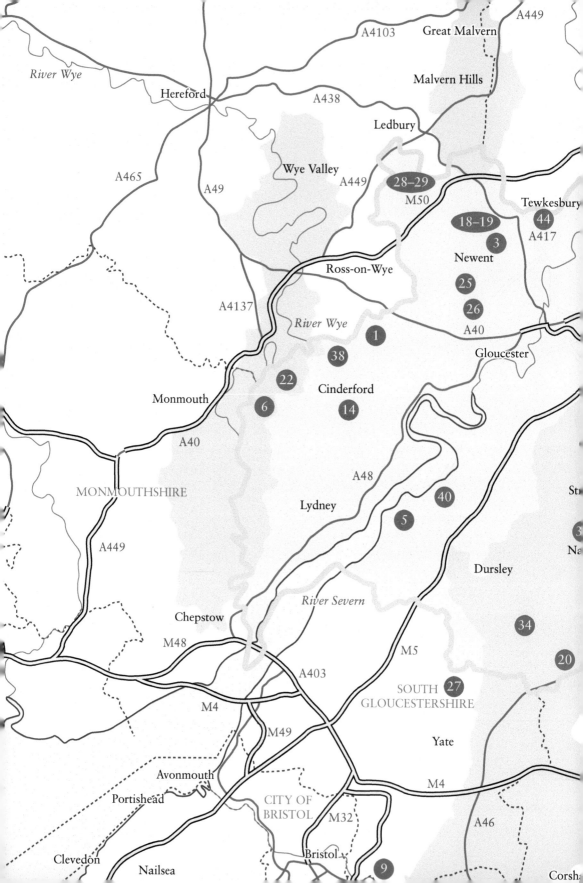

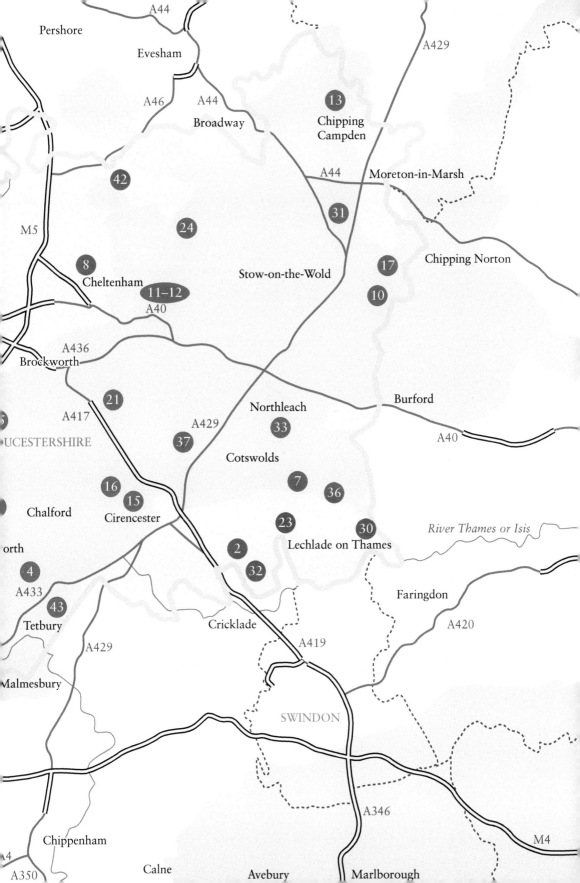

KEY

1. Abenhall
2. Ampney St Mary
3. Apperley
4. Avening
5. Berkeley
6. Berry Hill
7. Bibury
8. Bishop's Cleeve
9. Bitton
10. Bledington
11. Cheltenham, St Michael Whaddon Road
12. Cheltenham, Salem Baptist Chapel
13. Chipping Campden
14. Cinderford
15. Cirencester
16. Daglingworth
17. Daylesford
18. Deerhurst, St Mary
19. Deerhurst, Odda's Chapel
20. Didmarton
21. Elkstone
22. English Bicknor
23. Fairford
24. Hailes
25. Hartpury
26. Highnam
27. Iron Acton
28. Kempley, St Edward the Confessor
29. Kempley, St Mary
30. Lechlade
31. Longborough
32. Meysey Hampton
33. Northleach
34. Ozleworth
35. Painswick
36. Quenington
37. Rendcomb
38. Ruardean
39. Selsley
40. Slimbridge
41. Stroud
42. Teddington
43. Tetbury
44. Tewkesbury

PREFACE

Gloucestershire is a large county that lies between Worcestershire and Somerset and stretches from west of Oxfordshire to the Welsh border. Its landscapes reflect this extent. The county is dominated by two principal features: the River Severn, which bisects it into unequal parts, and the western end of the Cotswold hills. The bare uplands of the Cotswolds fall in an abrupt escarpment that plunges down into the flat lands of the Severn Vale, penetrated at intervals by deep, wooded valleys. The Severn, flowing south towards its estuary, is bridged in very few places, and the Forest of Dean, on the west bank, can feel separate, with its own distinctive character. Its steep hills, clothed in woods and bracken and bisected by narrow lanes, speak of Wales.

In contrast to the broad, tidal lower reaches of the Severn, the River Thames that marks part of the southern county boundary is in its infancy, rising from springs west of Cirencester, and skirting a huge Water Park created from former gravel pits, a modern construction around which can be found some of the most ancient churches in the county.

This watery world is very different from the tough sandstones underlying the Forest and the oolitic limestone outcrops in the Cotswolds. These limestones are part of the great sweep of Jurassic stone that runs in a curve from Dorset to Yorkshire, punctuated by many famous historic quarries. The quality of this stone, whether rough for walling or smoothly cut for windows and doorways, is outstanding: at times the buildings can seem to grow from the lands on which they stand.

Gloucestershire has many small towns and a few large ones, but despite its current rural character it shows traces of its industrial past, including mansions and churches built by its richer inhabitants. Around Stroud are many former industrial buildings that have been put to new uses. One of the charms of exploring the towns is the evidence of their most prosperous times, often seen in the houses and churchyard tombs. This book, though, is about churches and chapels. It looks at a small selection of urban and rural examples, dating from the Anglo-Saxons to the current century, chosen for their architecture and their contents such as liturgical furnishings, tombs, fonts and wall-paintings. Being a county with plenty of workable stone, Gloucestershire has some very fine tombs and memorials both inside the churches and in the churchyards, which are always worth exploring. There was much restoration as well as new building by some of the most distinguished architects of the Gothic Revival during the nineteenth century. Although some of their interventions can strike modern sensibilities towards conservation as extreme, it is to them that we owe the existence of many

fine churches that might otherwise have decayed beyond use. Much of their work
was informed by deep scholarship as well as a desire to design for themselves.

Most rural churches are fully open again after the pandemic, but churches
in towns may be closed for some of the time, depending on the availability of
volunteers to welcome visitors. Church staff are, however, keen to share their
buildings with enthusiasts, and almost every church now has a website, with
telephone numbers or other contact details, so visits can easily be arranged.

1. ABENHALL, ST MICHAEL

The wooded, hilly, slightly secretive Forest of Dean conceals many interesting
churches and St Michael's is one of them. Built of pinkish-grey Forest sandstone
and set in its rural churchyard, from the outside the building looks like nothing
in particular, but it has very good stained glass and Victorian fittings; above all, it
has a particular connection to the Freeminers Association of the Forest of Dean.
This body has a history going back centuries of representing those people who
were granted the right to mine minerals in the Forest, working independently and
on a small scale. On the outside of the west wall of the church is a plaque carved
in shallow relief showing symbols of the Freeminers, while the west window of

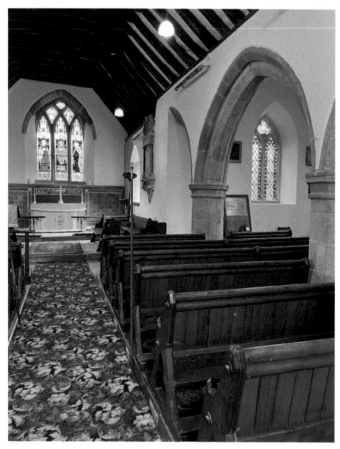

Interior looking east.

the tower now boasts a spectacular glazing design by Tom Denny, installed in 2011 and showing scenes of miners working in the Forest. The predominantly red, orange and blue colours reflect the minerals and the earth, with the figures and backgrounds done in Denny's characteristic softly impressionist style.

The solid west tower has a pyramidal roof, a useful landmark, and, with the font, dates to the fifteenth century. The font is probably the oldest untouched object in the building, which has otherwise been much restored. The simple interior has a thirteenth-century arcade between the nave and south aisle. The south aisle looks a little disjointed, and was in fact rebuilt in the eighteenth century; but this and subsequent restorations tried to emulate the medieval spirit of the church. The Victorian fittings are splendid: a Gothic Revival pulpit with roundels showing the symbols of the Evangelists carved in relief beneath small arches supported on short grey marble columns, and an altar reredos made of terracotta squares in alternating foliate designs in imitation of medieval diaper work. This is by Powell and Sons, who were also responsible for some of the other stained-glass windows. None of these is large or showy, but the quality of design and colour is outstanding. Note that some were left plain, with only a decorative border, which in sunlight enlivens the church interior with stripes of colour.

Right: Freeminers Association window by Tom Denny.

Below: The Freeminers plaque.

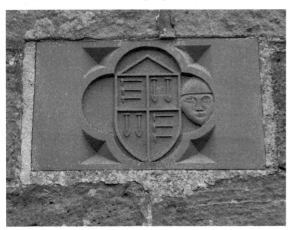

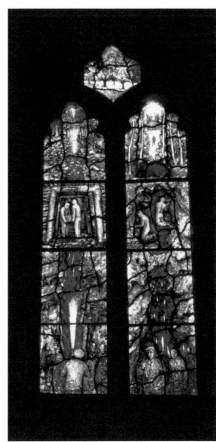

2. AMPNEY, ST MARY

St Mary's is not in Ampney St Mary village; it stands isolated in its large churchyard beside the A417 between **Cirencester** and **Fairford**. Its single-cell nave and chancel look a little sunk into the ground, and its square-headed windows give the impression of a late medieval building, but the nave is actually twelfth-century, as you can see from the blocked north door: the triangular tympanum writhes with Romanesque creatures, a lion and a griffin apparently triumphing over evil in the form of two benign-looking monsters with cat-like faces. The font, with chevron ornament, is also Romanesque. At the entrance to the chancel are low stone screens, a rare survival from the Middle Ages. Allow your eyes time to adjust to the copious traces of fifteenth-century wall paintings: some are architectural, with masonry lined out in red over whitewash and decorated with rosettes, but there are also remains of figured scenes. These include, on the south wall, another rare survival: an illustration of *Christ and the Sabbath Breakers* (see **Hailes**), with Christ surrounded by working tools that were not allowed to be used on Sundays. On the north wall you can just make out an elaborate scene of *St George and the dragon*, and a fragmentary St Christopher carrying the Christ Child. Their two haloes are close together at the top and provide a starting point for deciphering the rest.

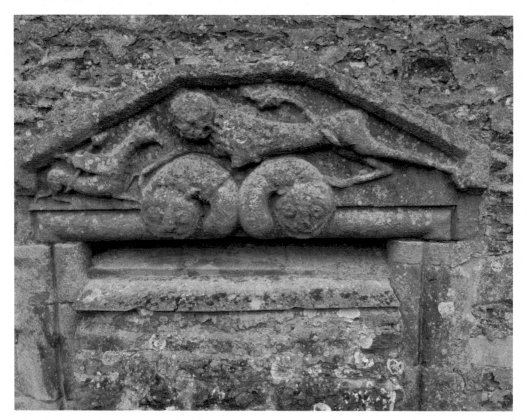

The tympanum of the north door.

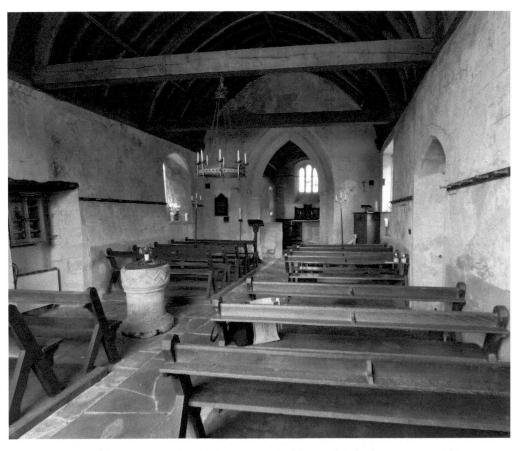

Above: Interior
looking east.

Right: Painting
on the nave south
wall.

3. Apperley, Wesleyan Methodist Chapel

The red-brick Methodist chapel sits beside a road out of the village, with a small car park beyond. It was built in 1903–4 to a design by J. Andrew Minty, but the Methodists had been established in Apperley since the late eighteenth century. They originally occupied a small chapel taken over from the Moravians, a short-lived pioneering Protestant movement that originated in Bohemia, and planted several communities in Britain and America. The Moravian building was retained, and stands at right angles to the Methodist chapel, but is now attached to a private house. Minty designed a simple, single-storey rectangular box with a pitched roof and projecting porch. Gothic wall buttresses sit between the four double windows in Perpendicular style, while the west gable boasts twin lancet windows. The curved ends of the gables give a slightly Dutch air, and decorative brickwork hints at the Arts and Crafts movement.

The interior has excellent proportions and good unobtrusive detailing that contribute much to its atmosphere of calm and welcome. The chapel was designed with seating in pews for 128 people, and most of the pews survive, along with the handsome pulpit backed by dark panelling. The communion table and two chairs in front of it were brought from elsewhere. The pitched timber ceiling is

The chapel exterior.

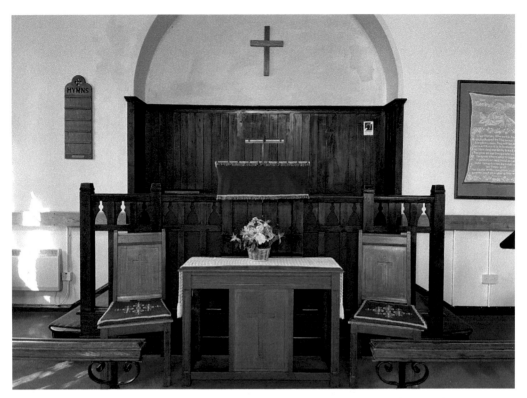

The pulpit.

particularly fine, mildly Gothic like the exterior and nodding to the Middle Ages in a typically Arts and Crafts manner: it is supported on arched braces that descend to quasi-hammer beams. Foliate motifs in stained glass adorn the window heads.

4. AVENING, HOLY CROSS

Avening is a hilly village, sloping up either side of the Aven stream; the church stands near the top of its steep churchyard. The ensemble of church and imposing trees is very attractive. From its beginning Holy Cross had royal associations, and its Romanesque core and later additions are of a quality to match, starting with the north entrance door. The north aisle, its arcade with scallop capitals on drum piers, was added to the single-cell nave in the later twelfth century; the central tower separates the nave and chancel, which has fine rib vaulting. The western bay is the original chancel, extended eastwards in the fourteenth century when they also opened up several windows with Decorated tracery, now restored: evidently no one wanted to rebuild the entire church at that time. Since little effort was made to smooth over the joins you can see the later vault supports alongside the original ones: the earlier are semi-circular, with moulded capitals and small carved 'tails', leading to crisply moulded slender ribs, while the later ones are polygonal cones supporting unmoulded, rounded ribs. The tower, with its solid Romanesque arch mouldings, opens into the north transept. The nave had altars either side of the

narrow arch into the tower, now marked by the remains of arches with projecting chevrons. These are among the many interesting Romanesque fragments to be found here and in the north transept: the small reliefs mounted either side of the entrance door are said to come from the original font, but may be safely attributed to a destroyed liturgical object. The glazing of two windows on the south side of the nave is by that very interesting artist in stained-glass Christopher Whall (d. 1924).

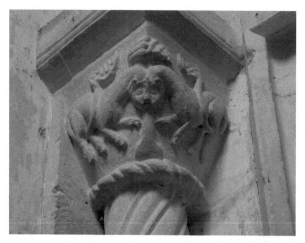

Left: Lion capital on the north door.

Below: The nave looking north-east.

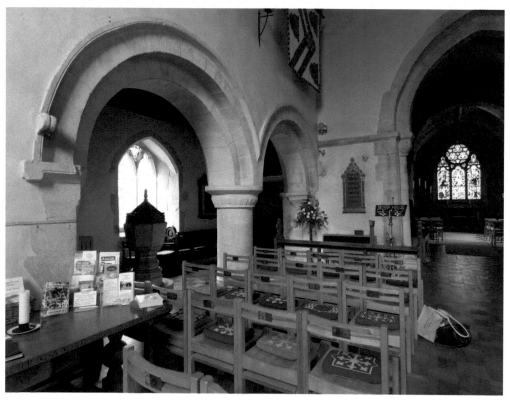

5. BERKELEY, ST MARY

The church, probably a former Anglo-Saxon minster, lies immediately north of Berkeley Castle. The first thing you notice is that its tower, an eighteenth-century rebuilding in late medieval style, stands around 250 yards north of the main building: its predecessor was possibly on the site of the eight-century church.

The building has an imposing nave and aisles of seven bays, and a decorative burial chapel for the Berkeley family off the chancel. Its bulky, austere appearance belies the splendours within. Start with the imposing west front, which has a window of five stepped lancets above a door with a cusped arch, flanked by gabled niches. The thin, detached Purbeck stone shafts between the lancets have delicate rings. Few monumental west fronts survive from this date, and it prepares the visitor for the superb thirteenth-century work inside: fine stiff-leaf capitals above quatrefoil piers, and carved head stops all along the arcades. Both nave and chancel have substantial remains of wall painting in architectural and decorative motifs, heavily restored (and therefore preserved) by the great Victorian firm of Clayton and Bell. The chancel screen is a rare survival of a stone medieval screen, restored by George Gilbert Scott, but the position of the stairs to the rood loft shows that much of the ensemble is lost. The tombs in the Berkeley chapel, which is closed off behind glazing, are difficult to see, but the

The west front.

chest tomb in the nave of the 8th Lord Berkeley (d. 1361), and his wife, depicted on a conspicuously smaller scale, is fine late fourteenth-century alabaster work, done at a time when alabaster was becoming a less popular material for effigies. The recess in the north wall of the chancel, enclosed in a big ogee arch, may well have been an Easter sepulchre.

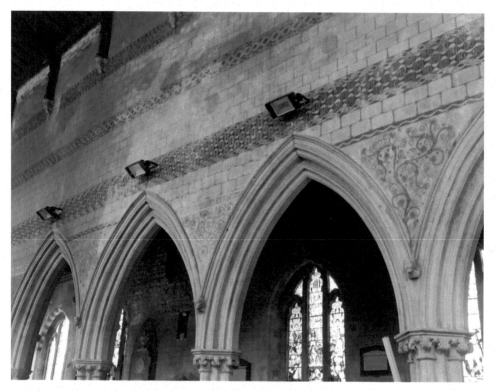

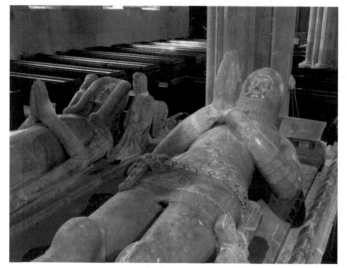

Above: Detail of the nave interior.

Left: Effigies of Thomas, 8th Lord Berkeley and his wife, Katherine.

6. BERRY HILL, CHRISTCHURCH

Right over on the western side of the Forest of Dean, Christ Church (like many others in the Forest) was built to bring religious instruction to the inhabitants, who were said to have no experience of 'the light of Christianity'. It is the earliest nineteenth-century church in the Forest, built in 1812 originally as a school and a chapel to impart both education and enlightenment. This became the north aisle of a bigger church constructed three years later.

What you see standing beside the road is a conventional-looking church façade built in stone, with a solid west tower in Perpendicular style and simple pointed windows to what appears to be an aisle. The tower was added by the rector in 1822 to the church of 1815. The interior, however, is a complete contrast to the Gothic exterior (compare **Cinderford**): there are two wide and well-lit aisles divided by very slender cast-iron columns. That the southern one is the nave is clear only from the sanctuary that opens from it to the east: a chancel consisting of a straight bay and a three-sided apse, admittedly small but a real separate chancel built in the period when such things were regarded with suspicion. It has a dark timber roof, which further differentiates it from the barrel-shaped ceilings of the two aisles. The two-light windows have simple ogival tracery in the Decorated style. The liturgical furnishings, plainly and cleanly made in light oak, were given over the course of the twentieth century in memory of various parishioners.

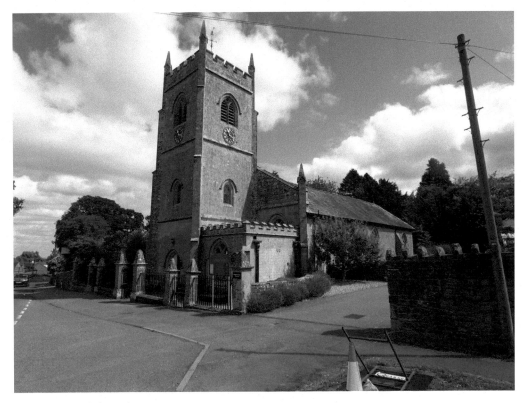

The church from the west.

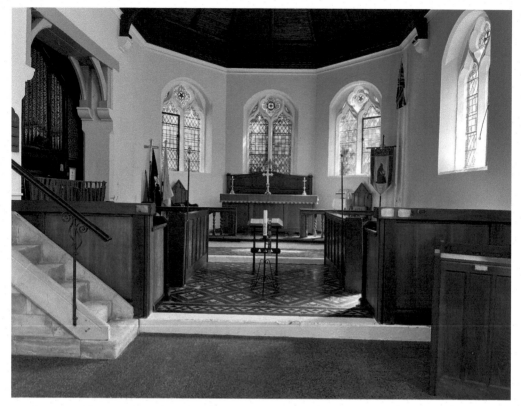

The sanctuary.

In the north aisle there are two excellent stained-glass panels, brought from elsewhere and possibly by the great Victorian firm of Clayton and Bell. Despite its very contemporary air, with chairs, movable furnishings, and a large kitchen area, Berry Hill is redolent of its history, an atmosphere that is summed up by the pulpit: made in 1885, it is adorned with panels commemorating successive vicars in honour of their energetic efforts on behalf of their church and the parish. Others are remembered in wall plaques.

7. BIBURY, ST MARY

Bibury is divided by a deep valley, along the bottom of which runs the River Coln, shallow, reedy and clear. The church lies slightly hidden from the main tourist area, only its tower visible, away from the waterfront and the crowds of daily visitors. Set in a neat churchyard, it is full of opportunities for architectural detective work. Its low roof and Perpendicular parapets and window tracery make it look late medieval, but it started life as an Anglo-Saxon minster church, of which many traces remain.

The Anglo-Saxon church had an aisleless nave leading through the usual narrow arch to the chancel. Both nave and chancel were expanded, the nave in the late twelfth century, when the arcades were inserted, with cylindrical piers and

capitals carved with stylized scallops, foliage and beading. The odd-looking strips on the upper wall of the north aisle are flat pilasters that survive from the original exterior wall. The remains of figures, corbels and doorways over the chancel arch may represent what is left of a rood screen; but the arch itself was raised in the thirteenth century, when the chancel was extended, with fine lancet windows.

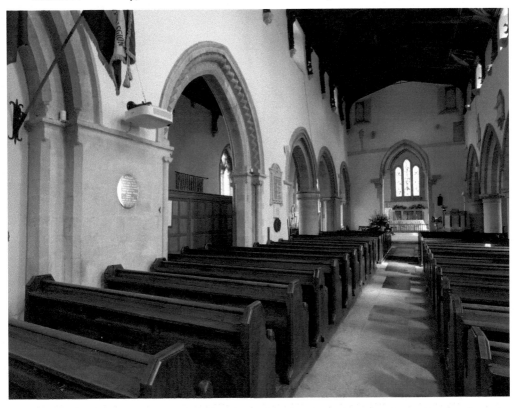

Above: Interior looking east.

Right: Capital of the north arcade.

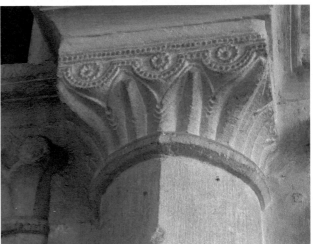

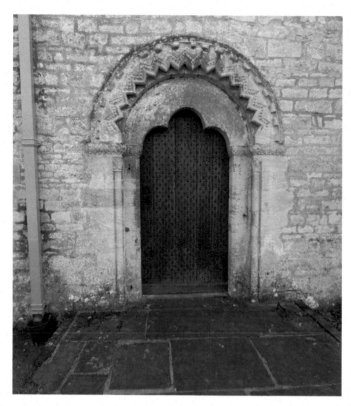

The north door.

Note the incongruity of the thirteenth-century arch atop square Anglo-Saxon jambs. Work continued in the early fourteenth century, with the elegant traceried windows of the north aisle, once a chantry chapel, now an outlet for second-hand books, crockery and glass.

The tower stands over the north-west corner of the building. Outside, continue round to the small door to the north aisle, a Romanesque confection of billet moulding, chevrons and beading, with a trefoil inner arch and monsters and foliage on the capitals; and finally on to the Anglo-Saxon gravestone decorated with interlaced circles, set against the chancel wall. Others were sent to the British Museum, but two casts are displayed in the south aisle.

8. Bishop's Cleeve, St Michael and All Angels

The medieval bishops of the prosperous see of Worcester held a manor here, which goes some way to explain the size and imposing presence of this large parish church. Yet before the Normans took it over, Cleeve had been an Anglo-Saxon minster, an important ecclesiastical centre, so its symbolic significance was already established. Nothing of the Preconquest church remains except perhaps the plan, with the tower placed centrally between the nave and chancel. St Mary's is full of diverting details and high-quality work of several periods.

The basis is a Norman church with aisles, transepts leading off the tower and a chancel. The Norman detail shows up particularly well in the big drum columns

of the nave, in several blocked windows and in some very good sculpture, particularly in the south and west doors. The arch of the south door has two elaborately carved orders supported on foliate capitals, an outer one of multiple chevrons and the inner a carefully regulated meander pattern. Around these is a hood moulding consisting of two snake-like creatures with tails intertwined at the apex and their grotesque heads at the base. More chevrons and a dragon and serpent enliven the west door. The south porch was added a few decades after the nave was built. It has two storeys, the ground floor lined by blind arcades of intersecting arches, while the vault ribs are flanked by more chevrons. The upper storey, known as the porch room, was possibly a priest's room and later used as a school. Its inner wall preserves part of the original corbel table of the nave exterior, consisting of carved heads in exceptionally good condition owing to centuries of protection from the weather.

The nave is extremely wide, and a good deal restored. The central tower collapsed and was rebuilt in Gothic style around 1700, and this may have been the moment when the original six bays of the nave were reduced to three, still with their cylindrical piers and scallop capitals, but with the arches renewed, though there are traces of chevron on the easternmost. Note here also the carved Norman doorways into the transepts and the traces of the original Norman roofline of the aisles, which show that their predecessors were much narrower than the existing fourteenth-century ones. For the other great period at Bishop's Cleeve is the

The nave corbel table in the porch room.

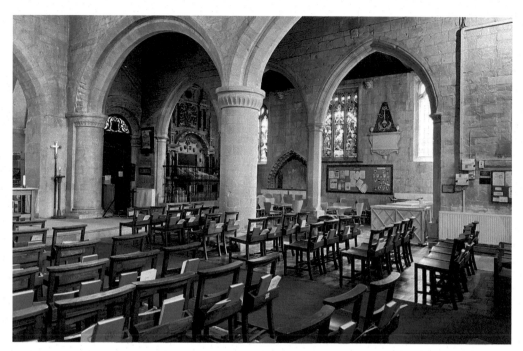

Interior of the nave and south aisle.

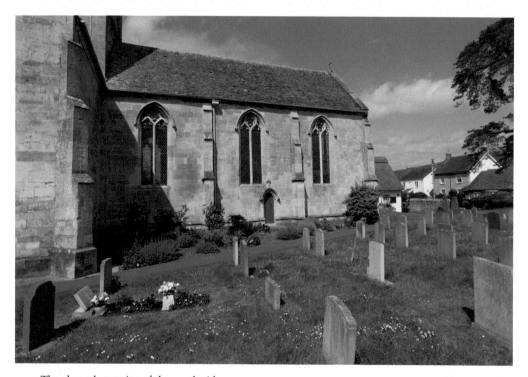

The chancel, exterior of the south side.

Decorated, with a huge new chancel, a delicate arcade into the south chapel of the nave and an almost complete refenestration with Decorated window tracery. This has been much restored, but the east window alone is a lesson in ballflower ornament and flowing tracery.

The narrow Norman doorways between the main spaces make the church feel like a series of separate rooms, each inviting exploration; and in each there is something to divert. In the north transept a narrow staircase leads to the bell chamber: built in the fifteenth century, it begins in stone, then turns a right angle up the west wall and continues in timber, a very rare survival of a feature that was ubiquitous when this one was built. In the south transept is a blocked Norman window painted in polychrome designs in the thirteenth century, and a tomb of a knight. The effigy is a little worn, but the tomb embrasure is an excellent example of Decorated work, with a big ogee arch, elaborate cusping, ballflower and foliate cresting. The big timber west gallery in the nave is Jacobean work. On the east wall of the south aisle chapel is the wall monument to Richard de la Bere and his wife. Bere died in 1636, but the couple are commemorated with rather stiffly pious traditional effigies and much moralising symbolism. Finally, back in the porch room are some monochrome black-and-white wall paintings, probably done in the late eighteenth century and the early nineteenth when the room was used as a school, featuring, among other things, a lion, a tiger and an excellently depicted skeleton.

9. BITTON, ST MARY

Bitton village lies right on the southern boundary of the county, on the former Roman road between Bath and Bristol, an island of rural peace between the busy suburbs of both towns. Roman remains were found under the church, which is large and tall for a parish church, and stands in a large churchyard: its size is explained by its past history as a significant Anglo-Saxon minster church, and later the centre of a much larger parish than the present one.

The building has three stylistically distinct parts, plus the fifteenth-century west tower, but the barnlike nave is complicated by the shadowy existence of its Anglo-Saxon predecessor, which is the basis of the walls and underlies the nave's height, width and length. East of the nave is the late fourteenth-century chancel, and at the west end on the north side opens a chantry aisle founded in 1298 by Thomas Bitton, bishop of Exeter but evidently a local boy. Each of these additions is interesting. The chancel has a tierceron vault of two bays rising to a ridge rib and divided by transverse arches that spring from the wall surface. Figured and foliate bosses cover the joints where ribs meet. The big five-light east window has uncusped traceries with a hint of the ogee curve.

Bishop Bitton's chantry aisle is a smart and fashionable addition, as befits an episcopal patron and the proximity of Bristol as a source of ideas and probably masons. It opens from the nave through two arches moulded with the rounded style that slightly resembles carved soap. While the capitals have standard moulded thirteenth-century profiles, the quatrefoil form of the column and the octagonal bases look fourteenth-century, as do the arch mouldings. Given that the aisle was built with its own entrance door at the west, the suspicion must be that these arches were broken through to the main vessel sometime after the chantry

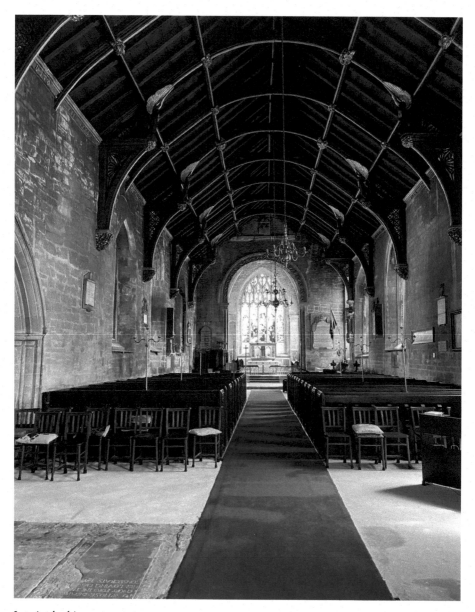

Interior looking east.

was finished. Its aisle windows, on the other hand, are lancets, but the inner side of the embrasures are decorated with cusping and finished with ballflower. This is precocious for the date, as is the seaweedy foliage that decorated the detached Purbeck colonnettes of the sedilia and piscina next to the altar.

The nave is full of puzzles and hints of earlier masonry. Fragments of surviving Anglo-Saxon detail can be found within it, but they have to be ferreted out from Norman rebuilding and nineteenth-century restoration. Two successive vicars,

Above: Windows in the chantry aisle.

Right: The chancel arch.

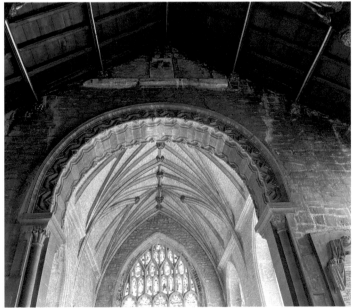

whose incumbency lasted between them from 1817 to 1916, were responsible for both studying and restoring (sometimes drastically) the nave we now see. H. T. Ellacombe studied the building, and his son, H. N. Ellacombe, restored it. He designed both the Norman Revival chancel arch that replaced the Saxon one in 1847 and the huge and ornate roof with hammer beams and angels in 1862. These two features now dominate the interior, and searching for the Anglo-Saxon ghost building becomes somewhat archaeological. The Saxon chancel arch was as tall as the present one, and its shadow may be seen alongside the nineteenth-century arch mouldings. Above it is a stringcourse supporting the remains of a carved Anglo-Saxon rood, that is, the Crucified Christ: only his feet and a curious dragon-like creature of indeterminate interpretation survive what must have been a big cross in the gable. This indicates the height of the minster church, just as fragments of demolished *porticus* chapels give the width. H. T. Ellacombe established that the original church was longer than this one. The walls themselves seem to be at least on the line of the Anglo-Saxon walls, but doors and windows were punched into them in later centuries. One is inaccessible but the other can be seen on the exterior of the south side, a late twelfth-century door with foliage capitals.

10. BLEDINGTON, ST LEONARD

Bledington is just inside the country boundary bordering west Oxfordshire, and not far from the great limestone quarries around Taynton and Chipping Norton. The church shows this. There is something very satisfying about it as it sits comfortably in its churchyard, solid yet light, giving off the indefinable glow of the local stone. There are some remains of the Norman church, and the east window was made in the thirteenth century when the chancel was extended and the south aisle added, with thick, chamfered arches and moulded capitals on cylindrical piers. Nevertheless, the overwhelming impression is late Perpendicular, and what catches your eye as you enter through the south door is the extraordinary north wall of the nave. Sometime probably in the late fifteenth century the clerestory was added, and the north wall was opened up into a series of square-headed windows, three large ones and a smaller one crammed in over the north door. They have simple mullions topped by teardrop tracery that hardly interferes with the glazing panels. The latter were given over to what were evidently elaborate programmes of stained glass, of which little of what remains is identifiable. Mostly collected in one window, the glass is fragmentary, but a figure of St Christopher stands out, together with the Virgin Mary holding a sceptre and a rosary. The window embrasures are embellished with niches for statues: canopies in the form of the nodding ogee, which bends forward into space, and polygonal pedestals. The nodding ogees give an old-fashioned air to these canopies, since they are a throwback to the heyday of the fourteenth-century Decorated style. It is possible, but not proven, that they imitated the east window of the south aisle, which may be a former Decorated window remodelled at the same time as the north wall. Tucked into the south-west corner of the chancel and accessible from the aisle is a niche with its own window, a flat-panelled vault and a curtain of openwork tracery, said to be a chantry for the Hobbes family.

There are traces of wall paintings in both the nave and the chancel. Taken together, all these features, although fragmentary and stripped of their functions,

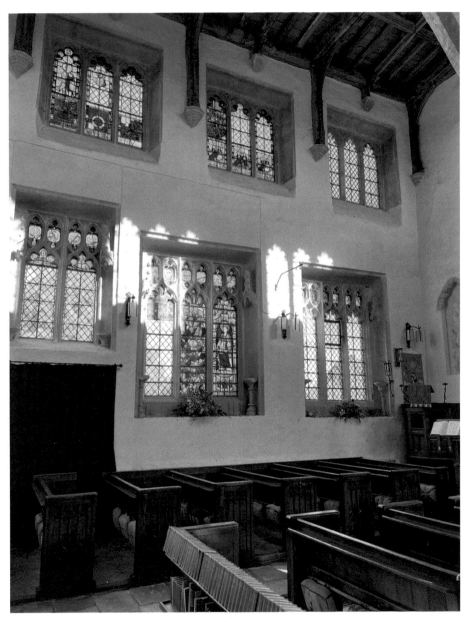

The nave north windows.

give a vivid impression of what an ornate parish church interior would have been like before the Reformation.

Bledington offers one more surprise: the tower. This appears to have been built inside the original west bay of the nave. The last bay of the arcade opens into the tower, which has its own arch built inside it. This is best seen from just inside the church door, since later insertions, including the organ, have rather blocked it.

CHELTENHAM

A large town, Cheltenham has many churches and chapels. I have chosen two modern ones, built within recent decades.

11. UNITED SALEM BAPTIST CHURCH

This is a new chapel, built in 2000 by Ralph Guilor Architects, when the Baptists had to move from the chapel in the centre of Cheltenham that they had occupied since 1847. The building is a complex one, with many ancillary offices and a sports hall behind the chapel proper. The chapel, which is set on a north-south axis, fronts the street, a flat wall under a single wide gable, with three tall windows between solid brick pillars.

The interior is an excellently proportioned, lofty single space, the proportions best appreciated from the big gallery at the rear (north) end. The timber roof is supported on cruck trusses that rise from the floor and meet at the apex of the roof. Although there are traces at floor level of much daily activity, the deceptively simple design imposes an atmosphere of calm and peace. The south-facing wall onto the street is the liturgical east, with the dais, the cross in the central window, pleasant light oak furnishings brought from the former chapel, and hangings

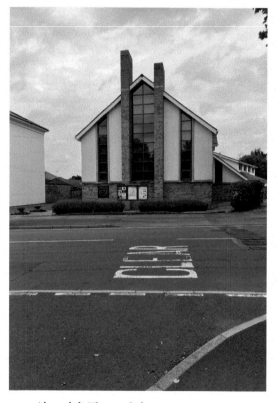

Above left: The south front exterior.

Above right: A cruck post supporting the roof.

Decoration of the tank cover.

symbolising the Pentecost and gift of tongues. At the foot of the dais three wooden covers conceal the baptismal tank; the central one has an inset design of a dove.

12. UNITED CHURCH OF ST MICHAEL

St Michael's is an example of mid-twentieth-century church architecture, designed for a corner site by Stratton Davis. Begun in 1965 and consecrated a year later, its lower storey is buff-coloured brick, but once you are inside the overwhelming effect is of timber, for the interior is essentially timber-framed and the fittings are made of many different woods.

The church is hexagonal, with the west entrance side at 45 degrees to the street corner, fronted by a canopy that apes on a small and shallower scale the deeply folded green copper roof of the main building, each fold embracing a large triangular window above the brick skirt. Inside, the corners of the hexagon form prominent ribbed semi-cones leading to the apex of the roof. The ribs are of timber, supported on solid concrete bases, and the windowsill is a continuous timber ring beam. Despite the gallery on the west side and the crowded furnishings, there is a striking impression of an all-embracing unified space with abundant light.

The altar, in its square, railed sanctuary, stands beneath a tall, plain, baldacchino or canopy, a form that traditionally marks as sacred the space beneath. The hexagonal font is the work of Dinkel Keet, who also engraved the manifests on the glass entrance doors. The font is faced in slate with incised designs and inscribed on the rim with the opening verse of Psalm 42.

The chief glory, though, is the timber. Wood was drawn from around the world to make the fittings: the main timbers are Scandinavian spruce, the floor is of teak from Burma, Afromosia and Dousse came from Africa for the sanctuary furnishings, while the folded panelling of the altar screen is made of Ghanaian Avodire. Mahogany from Honduras was used for the font cover. Subtle shifts in the colour and texture of the different woods bring the whole interior alive.

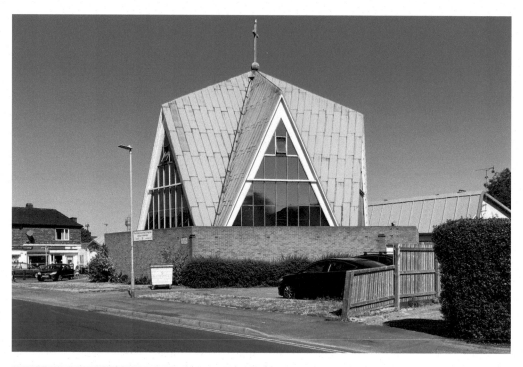

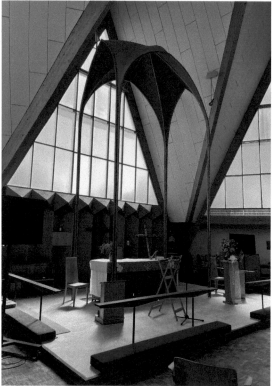

Above: The church exterior.

Left: The baldacchino.

13. CHIPPING CAMPDEN, ST JAMES

St James is one of the so-called 'wool churches', built from the profits of the Cotswold wool trade. It is apt to be associated with prominent recorded wool merchants in the town, particularly William Grevel, whose memorial brass is in the chancel and whose remodelled house stands prominently in the High Street. Grevel, however, died in 1401 and the present church dates from well after his death. Its position, detached from the main street and rather screened by trees, is raised up, announced by its square, battlemented tower, which proclaims a fifteenth-century date. Probably in the mid-century the nave was rebuilt and the entire exterior was clothed in consistent refacing that hid shallow roofs behind battlements with pinnacles, and provided big Perpendicular windows with relatively small tracery heads above tall lights. Within the uniformity, however, you can find substantial traces of earlier work. The outside walls date substantially from the thirteenth and fourteenth centuries.

The light-filled aisled nave gives the impression of elegantly moulded weightlessness in keeping with the late medieval taste for thin-walled structures that supported timber roofs rather than the complicated pressures of stone vaulting. The octagonal piers with concave sides, very like those at **Northleach**, support capitals with a similar profile, expressed in sharply edged, moulded layers.

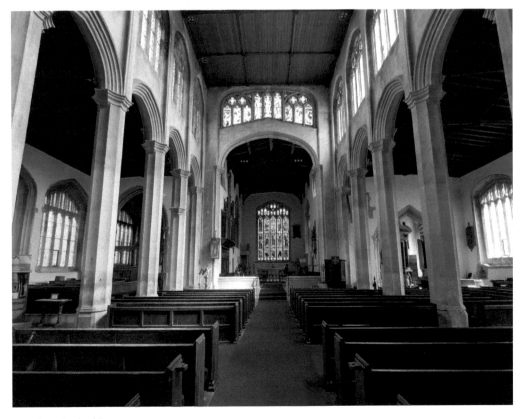

Interior looking east.

It is above the capitals, however, that the structure becomes interesting. The arches are as closely moulded as the capitals, and there is little plain wall between them and the base of the large clerestory windows. This might be considered a useful way to economise on stone, until you see that rising from the inner faces of the capitals are flat pilasters that support plain arches projecting forwards from the plane of the clerestory glass. The upper wall, therefore, has two planes, thin above the arcade arches, thickened between them. As in a few other Cotswold churches the clerestory continues across the east wall above the chancel arch.

In the Gainsborough chapel on the south stands the immense tomb of Sir Baptist Hicks (d. 1629) and his wife, ancestors to the Earls of Gainsborough. Hicks built the short-lived mansion south of the church; among its surviving traces is the elaborate entrance gate beside the pathway up to the church. Hicks also gave the pulpit and lectern to the church. The tomb consists of a white pediment standing above grey marble columns, enclosing the black tomb chest and abundantly carved effigies. It is worth persevering to find the other beautiful seventeenth-century memorials in the same chapel, as well as the many memorial brasses to merchants other than Grevel, all of whom may have made their own contributions to the rebuilding.

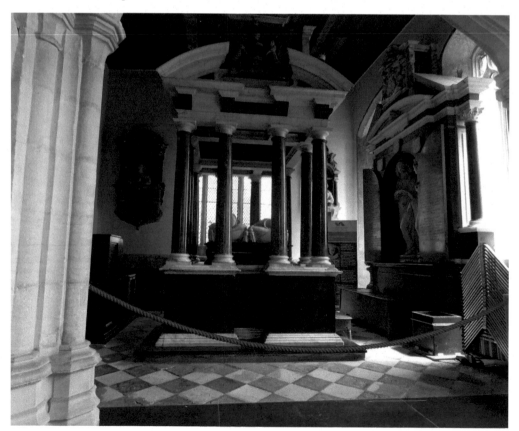

Tomb of Sir Baptist and Lady Hicks, *c.* 1629.

14. CINDERFORD, ST JOHN

Cinderford is deep in the Forest of Dean. St John's Church, once the first and central parish church of the recently established mining community of Cinderford, is a fine Gothic Revival building designed by Edward Blore and built in 1843–44. The town developed northwards, the industry died out, and now the church lies on its southern edge. It is set halfway down the slope of a large, hummocky churchyard containing many fine nineteenth-century tombs and headstones, and it is almost hidden by huge conifers that were planted when the church was built, with two avenues leading to the north and south transepts.

The church is built of dark local stone, rather ruggedly finished, with short transepts and an apse at the east. Its tall lancet windows are in a restrained thirteenth-century style, and together with the apse they show careful attention to medieval precedent in the spirit of the Revival movement in the 1840s, which was led architecturally by Augustus Pugin and George Gilbert Scott, both of whom believed that Gothic was the true Christian style and that accurate study of its details was essential. The reintroduction of chancels as an architectural feature was part of this Christian revival, but medieval Gothic apses are rare in this country, so Blore was nodding towards French design.

Money, however, was tight, and Blore did not continue with expensive stone for the interior. Here his design was highly unorthodox for an apparently stone

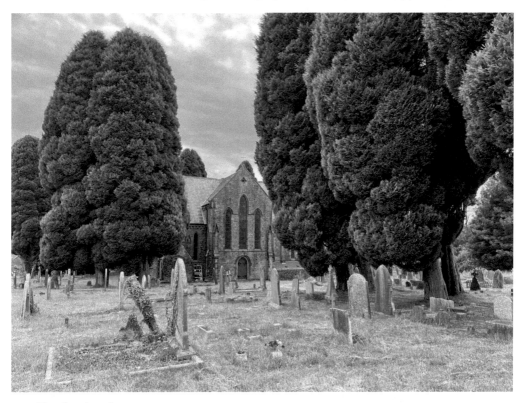

The churchyard.

Left: Interior looking east.

Below: The altar.

Gothic structure: within the stone shell he constructed a timber-framed building, the open trusses supported on thin, tall wooden piers, except for those of the crossing, which are more substantial. Were it not for the liturgical fittings you might be standing in a barn. The assorted stained glass provides splashes of colour on the pale, monochrome wash on the nave walls. Alterations were made later, a particularly beguiling one being the insertion of a west gallery in the 1870s, supported on thin cast-iron columns, one bearing the maker's name, adorned with Gothic foliage and capitals. The altar and reredos, the organ, the sanctuary screen and the choir stalls were all made early in the twentieth century. The ceiling of the sanctuary was painted as late as the 1940s. Yet all the additions respect the original, and the overall effect is consistent and oddly light-hearted.

15. CIRENCESTER, ST JOHN THE BAPTIST

Owing to its large size and dominant position in the marketplace, you could imagine that St John's Church is the ultimate expression of mercantile wealth in a town made prosperous by the medieval wool trade. In fact, Cirencester was owned by its very rich and powerful abbey, and the townspeople had to struggle for their rights until the late Middle Ages. They were able to impose themselves on the parish church only from the fifteenth century. The tower, started shortly after 1400, tall, decorated in blank Perpendicular panels and a battlemented parapet, is a beautiful landmark, visible from many points including within Cirencester Park, the layout of which is partly focused on it. The lacey finish of the parapet looks

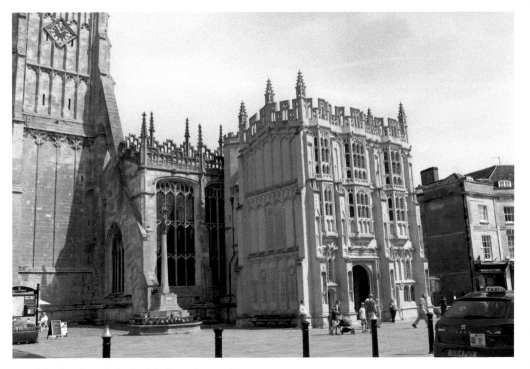

The porch and south aisle from the south-west.

particularly beautiful as the sun declines in the afternoon. Up close to the tower, however, the huge buttresses and signs of panic-stricken alterations at the west end of the nave show that the tower, or its footings, caused subsidence early on.

The enormous south porch that fronts the marketplace resembles the grander form of monastic gatehouse; it was built around 1500 with recorded contributions from wealthy townspeople. It has three bays of different widths, topped by an openwork parapet, and blind tracery panelling between the big oriel windows. All this is stylistic sleight of hand to conceal distinct phases in the building, since it was built out from a more modest porch that survives between the main part and the door into the nave.

George Gilbert Scott restored the church proper in 1865 with his usual scholarly thoroughness combined with contemporary ecclesiological opinion. Timber galleries and box pews, introduced after the Reformation, were removed, and the interior's current appearance owes much to Scott. The six-bay nave is as wide as it is long, and very high, which makes the chapels at the east end of the church seem pokey and dark by comparison. But they came first, and there are the remains of earlier phases amid the later rebuildings, especially in the chancel, where the earliest feature is a reused Roman column: Cirencester is famously a Roman town. Also here are features surviving from the chancel's Norman predecessor. All four of the east end spaces were subject to continuous reworking, and often lengthening, from the twelfth century onwards. The chancel and the Lady chapel on the north were originally separate, but the chapel of SS Catherine

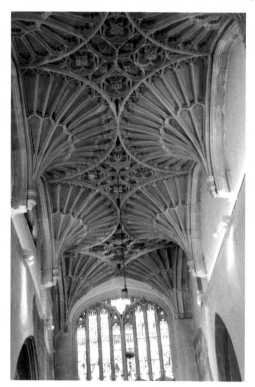

The vault of the chapel of SS Catherine and Nicholas.

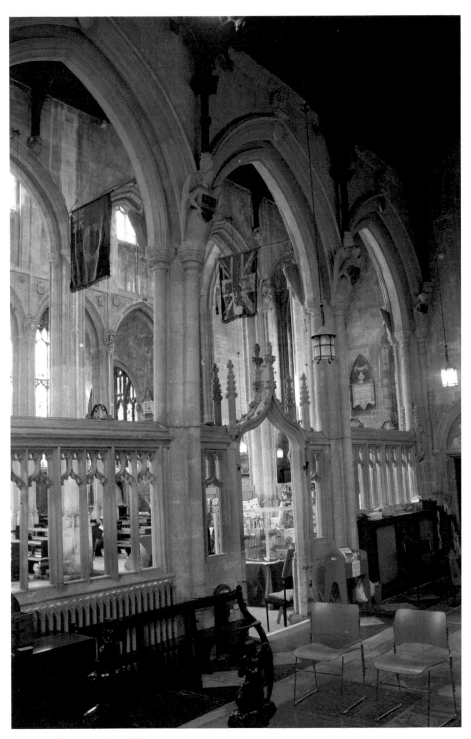

The nave from the Holy Trinity chapel.

and Nicholas was created between them by roofing over the space. This chapel was adorned with a fan vault early in the sixteenth century, which is beautiful but does not fit very well, leading to speculation that it was brought from elsewhere. It is equally likely that the mathematics of the vault were incompatible with the existing structure. The remains of a niche and wall paintings are all that is left of a former shrine, a small reminder of what was common in churches before the Reformation.

In any parish church, especially a large one, you would expect that the aisles to the nave were intended as chantry chapels for prayers for the souls of the laity, but here the townspeople were kept out until late on. The big four-bay chapel of the Holy Trinity was built into the north aisle from the 1430s not by merchants but by two household knights of Richard, Duke of York, father of King Edward IV: one of them, William Prelatte, is commemorated by a brass showing him between his two wives, now partly covered by the altar. In the south aisle is the first sign of merchant involvement: the Garstang chapel, founded by the Lancashire wool merchant Henry Garstang (d. 1464) and marked not architecturally but by a magnificent wooden screen, now back in its rightful place having been put to various uses in other parts of the building (and moved back after Scott's time). Yet it was only from 1514 that the townspeople inserted the new arcade and clerestory within the shell of the former nave: very tall piers with slim mouldings that match the orders of the arcade arches, and a tall clerestory, slightly set back as at **Chipping Campden**, with a false middle storey in the form of flat panelling. The panelling and the tracery are continued across the east wall above the chancel arch, perhaps the latest example of this idea, as seen also at **Chipping Campden** and **Northleach**. Angels set between the arches display arms of the leading families, who undoubtedly helped to pay for the building. Preserved for the new nave was the handsome stone pulpit, made around 1450 with openwork panelling in a tulip-like cup shape.

Opposite the Garstang chapel a glass-fronted niche displays the 'Boleyn' cup, a vessel made in 1535, traditionally for Queen Anne Boleyn, in silver-gilt with the very latest Continental designs in ornament. Among some very good tombs is that to Thomas Master in the Lady chapel, who died in 1680; his effigy reclines comfortably on the tomb chest. In the south aisle is the marble monument to the wool merchant and Sheriff of London George Monox (d. 1638) and his wife, kneeling under a broken pediment, with their mourning daughters below.

16. DAGLINGWORTH, HOLY ROOD

Daglingworth is a wonderfully surprising church; do not be put off by the obvious and, in places, quite obtrusive restoration, including the addition from 1845 of the entire arcade and north aisle of the nave. For Daglingworth is fundamentally Anglo-Saxon, as you will see from the tiny round-headed window in the nave wall as you approach the later south porch. Fragments of Anglo-Saxon walling and details survive in the porch, as does the original south door and some long-and-short work supporting the corner of the chancel. Inside, the chancel arch is narrow, with block-like capitals; and next to the altar, an apparent credence table is almost certainly the reused altar from the Romanesque period.

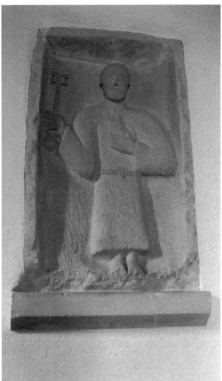

Above left: The chancel arch.

Above right: Relief sculpture of St Peter.

You are here primarily for the extraordinary surviving panels of relief sculpture, relocated in separate parts of the nave but perhaps originally on a screen, and dated by different scholars from the ninth century to the eleventh. Represented are the *Crucifixion*, the *Crucified Christ*, *The Resurrected Christ Blessing*, and St Peter with the fine bunch of keys that is his attribute. The *Crucifixion* in particular, which depicts the two soldiers, Stephaton and Longinus, who succoured the dying Christ, exemplifies the arrival of Mediterranean iconography into this country during the Anglo-Saxon period. Elegant the style is not, but the sculptures are carved with force, simplicity and conviction, and they remain long in the mind.

17. DAYLESFORD, ST PETER

A wonderful small church, tucked into a secluded churchyard, built in the early 1860s by the great architect John Loughborough Pearson in his version of early Gothic, a hybrid French and English style. He built it for Harmon Grisewood, then owner of Daylesford House, to replace one built for Warren Hastings in 1816. Both men are finely entombed in the churchyard east of the church. The south door is almost the only trace of the Norman church that had been rebuilt by Hastings; Pearson preserved it again.

Above: Mosaic in the chancel.

Left: The south transept screen.

The church is cruciform, with a central tower, and no aisles. Architectural ornament abounds. The windows are adorned on the outside with applied shafts, and gables and pinnacles over the three eastern lancets. The tower windows are set deep within arches surmounted by tall gables that penetrate the steep pyramidal roof. Buttresses and expanses of walling are treated with motifs in low relief. Inside, the decorative details, especially the stone sculpture and the mosaic decoration of the chancel, are beautifully rendered, as are the metal screens at the entrances to the small transepts. The crossing has four emphatic arches. Its main piers are ornamented with polished marble shafts in dark and light grey, and there are further little marble columns around the font. The quality of the finely rendered stiff-leaf foliage sculpture, on both large capitals and small ornament, is extremely high. The pulpit is appropriately carved with scenes in relief of biblical figures preaching. The stained-glass windows, done in bright, clear colours by Clayton and Bell with scenes from the Old and New Testaments, are essential to the complete expression of the High Church values of the time. The church has recently been well and tactfully restored.

Interior looking east.

DEERHURST

Deerhurst, a fifteen-minute drive from Tewkesbury, boasts two Preconquest buildings of great interest: St Mary's Church and Odda's Chapel.

18. ST MARY

St Mary's Church, founded perhaps in the seventh century, is renowned for both its architecture and its sculpture. Its building history is complicated: the expansions from the simple original building are best studied on the excellent information boards inside the church. The approach from the south suggests a late medieval church, with only the west tower and patches of Anglo-Saxon herringbone masonry hinting that something else is enshrouded in the later stonework.

Do not ignore the beautiful late Romanesque capitals of the main arcade or the excellent later window tracery in the aisles; but what surrounds them is the substantial trace of the Anglo-Saxon church, with remains of its flanking *porticus*, the burial chapels built alongside the original main vessel, now mostly converted to aisles. Only the north-east chapel gives an idea of them. Tantalising scraps are everywhere, beginning with the beast head over the west door, and the two heads of growling dragons on the door into the nave, with full sets of teeth, incised decoration reminiscent of contemporary metalwork and with traces of paint.

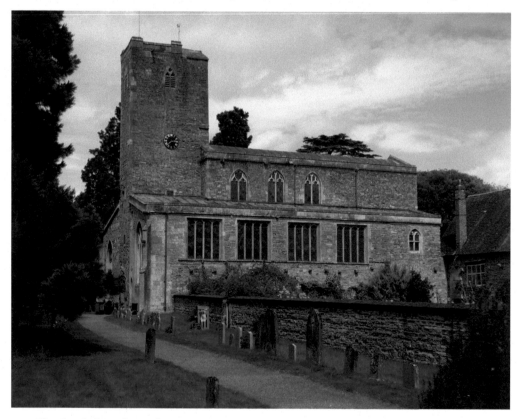

The church from the south-west.

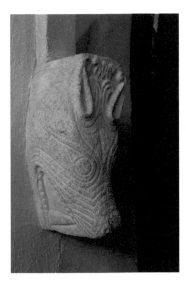

Above: Beast head on the west door of the nave.

Right: Interior looking west.

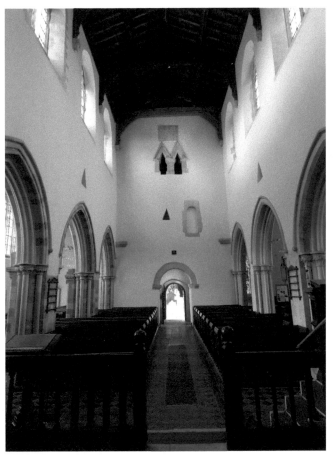

The spiral decoration on the font hints at metalwork, too. Set high in the interior walls are triangular-headed openings that once led into upper floors or galleries that were subsequently destroyed. The most remarkable of these is the double window high on the west wall, which has gables, and squat, fluted columns supporting stepped and squared capitals. They show familiarity with contemporary work on mainland Europe, as does the relief of the Virgin set in the west porch.

The chancel arch is blocked off, and outside, if you go round to the east end, you can see why: the chancel ended in a seven-sided apse, the foundations of which have been exposed and are worth a look in themselves; but on the south side is a remaining length of projecting choir wall, which displays the famous relief carving of an angel, carefully signposted and not to be missed.

19. ODDA'S CHAPEL

Odda's Chapel, a short walk from St Mary's Church, was built, according to an inscription, by Earl Odda in 1056, just before the Norman Conquest. It is a remarkable survival, extra valuable from its known date and later history. The chapel was subsumed into a private house to which it is still attached; it was

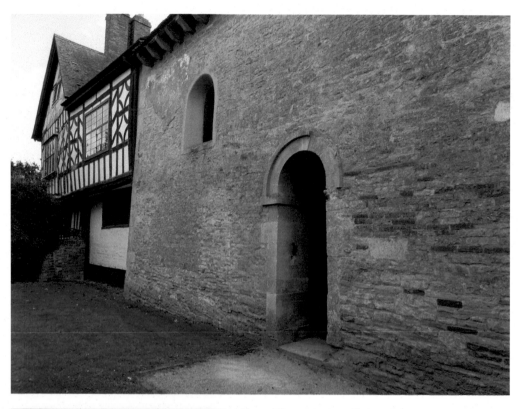

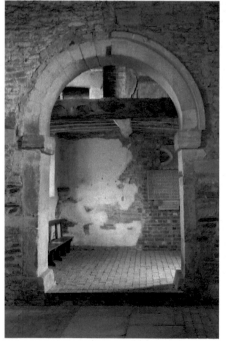

Above: The entrance wall.

Left: The chancel arch.

rediscovered in 1885, and restored in 1965. The small rectangular building has a plain rubble exterior with small round-headed windows and a narrow doorway with a square-cut, slightly horseshoe-shaped arch and block capitals above square jambs with long-and-short stonework. The tall, narrow interior is typical of single-cell Anglo-Saxon churches. It is as plain as the outside, with remnants of the original wall plaster, and divided into a nave and small chancel by an arch wider than but very similar to the entrance door. You will find the inscription in the chancel. Wooden beams are among surviving traces of the chapel's use as a house.

20. DIDMARTON, ST LAWRENCE
St Lawrence looks ordinary from the outside, and since the churchyard is screened from the road by trees you might miss it altogether; but stop and look, for the inside has that comparatively rare thing, a full set of original Georgian liturgical furnishings, which tell the story of Anglicanism before the Victorians revived

Interior
looking east.

The thirteenth-century piscina.

pre-Reformation practices. The church is now L-shaped, a north chapel having been added to the original aisleless Norman church in the late thirteenth century, boasting its own traceried window. This arm is topped by a pyramidal bellcote. The simple Norman building made a perfect setting for the installation *c.* 1809 of the new fittings, in an era when the ideal church was a rectangular preaching box without a chancel. Lit by large round-headed windows, the nave is dominated by the three-tier pulpit and reading desk, set between two windows, all encompassed by a wide arch supported on classical pilasters. The box pews seem to cower beneath.

Behind the altar table on the east wall is a handsome wooden board displaying the Ten Commandments. This replaced a Georgian predecessor, which is now at the back of the church. Either side of this tiny sanctuary are stalls for the choir. Everything is painted a uniform light green, except for the tester over the pulpit, and all has been conserved for the future. Right of the altar is a small, trefoil-shaped piscina, a survivor from the medieval arrangement.

Coat hooks set high on the western walls are evidence of a former gallery, and below them are several beautiful and engaging memorials dating from the seventeenth century to the nineteenth. There are some splendid chest tombs in the well-populated churchyard.

21. ELKSTONE, ST JOHN

What you see first of this church, tucked down slightly below road level, is the elegant fifteenth-century west tower that replaced the original central one, with the remains of an image niche above the door, representing the many such niches that have been lost. But St John's is Romanesque, with corbel tables on the north

and south sides, and elaborate carving round its small east window, both inside and out. It dates probably from the third quarter of the twelfth century, when architectural sculpture had become rich and refined: motifs could be foliate, geometric, animal or abstract, and at Elkstone you find a varied selection.

The bay that supported the original central tower separates the nave from the chancel: the arch has scalloped capitals and is elaborately carved with chevron, and an outer hood moulding ending in beast heads distinctly reminiscent of those at **Deerhurst** (though the Elkstone examples may have been added by the

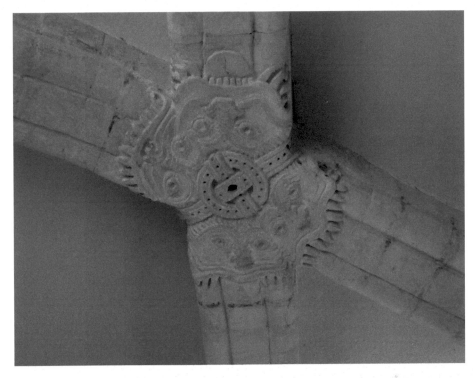

Above: The chancel keystone.

Right: The lion corbel supporting the chancel vault.

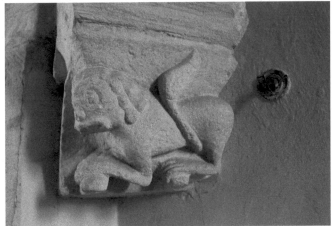

nineteenth-century restorers). More chevron leads to the chancel, which has a solid, square-profile quadripartite stone vault, the keystone of which consists of four cat-like heads joined in the centre by a buckle motif, all in very flat relief. This is so diverting that you might miss the charming lion on the north-east vault console, perhaps representing St Mark, the sole survivor of the Four Evangelist symbols. The east window is framed by a foliate hood moulding and chevron enclosing rhomboid rosettes.

A staircase leads to a space under the chancel roof that once served as a dovecot or *columbarium*.

22. ENGLISH BICKNOR, ST MARY

A church in the Forest of Dean, standing, as often around there, in a large, well-kept churchyard. The battlemented west tower has been altered many times, as you can see from blocked windows at every level, and the exterior generally gives no idea of the glories within. For this is a Norman church, restored in the late nineteenth century by F. S. Waller, who was responsible for much work in Gloucestershire and, although ruthless at times by our standards, did conserve much that might otherwise have been lost.

The tower being at the west, the arcades run through to the east with the division of nave and chancel marked only by the screen. The nave has five bays

Interior looking east.

Right: The reset doorway in the nave.

Below: The tomb effigies in the north aisle.

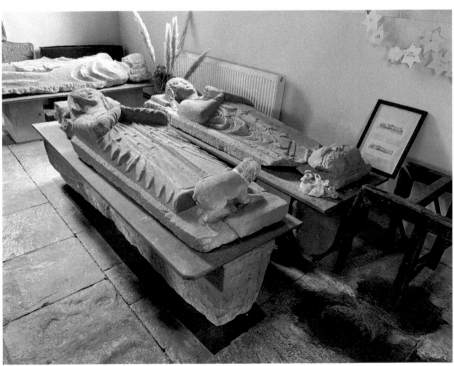

of plain round arches on solid cylindrical piers; the square-topped capitals are carved with scallops, or rudimentary crocket capitals (with volutes at the corners and centre of each side), which suggest a date towards 1200, when such forms were being imitated from French buildings. The surprise is the last arch at the east of the north arcade. This is clearly a doorway that has been reset, and its sculpture is much more elaborate than in the rest of the church. It is partly obscured by the pulpit, but you can peer round from the north side. It has a slightly moulded hood, then an outer order of projecting chevrons below a roll moulding clasped by beakheads – beasts with long beaks that clasp the moulding. Here they are in the form of almost identifiable animal heads, slightly abstracted like those of teddy bears. The inner order has incised geometric patterns and the arch is supported on cushion capitals (square at the top, refined to circular below) decorated with beading, semicircles and partial scallops, with a fine twisted ring at the bottom.

The church boasts three effigies made by local sculptors, all conserved and rather neatly tidied away into the corner of the north aisle. The carving of the priest is indeterminate, but more detail survives on the two ladies, who have been tentatively identified and dated around thirty years apart in the early fourteenth century. Their faces are simply carved and they lie stiffly beneath somewhat rigidly defined drapery. The one who may be Cecilia de Mucegros, who died in 1301, has a loop of cloth over her arm and holds her heart, which usually indicates a heart burial; Hawisia de Bures, dated to the 1340s, has her feet resting conventionally on a dog.

23. FAIRFORD, ST MARY

Fairford church is rightly famous for its set of outstanding early sixteenth-century stained glass, most of which survived the Reformation, puritanism a century later, and the normal decay of passing years that led inevitably to some restoration. The theme is a presentation of the *Incarnation*, *Life* and *Passion of Christ*, with Prophets, Saints and Fathers of the Church, culminating in a splendid west window of *The Last Judgement*. As well as being of very high quality, the glazing programme offers a visualisation of late medieval Christian thought that can now rarely be seen in our churches. The exact date and attribution of the glass is still debated, but the church is very well equipped with an excellent audio guide to its history and subject matter, both too extensive to discuss here, and visitors are strongly recommended to take advantage of it.

The present church was built probably in the late fifteenth century. Large, spacious and consistent in Perpendicular style throughout, it stands in a large churchyard at the top of the medieval marketplace. Traces of its predecessor can be seen in some mismatched footings on the east wall, rooflines of demolished transepts on the tower, and in the tower itself. This is central, standing solid and foursquare between nave and chancel, and work from the earlier church is visible at its lowest level inside. The existing church was essentially built round it, and the masons undoubtedly found it difficult to adapt the tower to their new, transept-less plan. Differences between the two sides of the arch into the shallow chancel show that problems arose there, too, perhaps owing to attempts to realign the building more accurately.

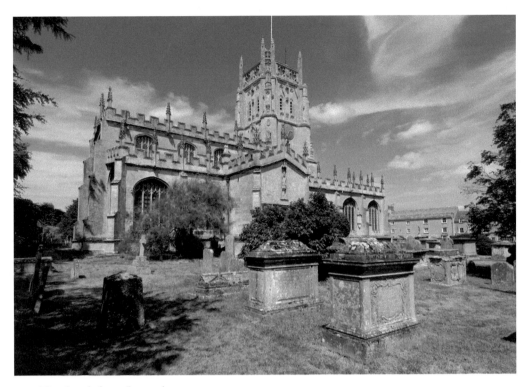

The church from the south.

St Mary's is undocumented. Its date is speculative, and the building is beset by persistent and inaccurate legend, much concerning the stained glass, but also the architecture. The church is attributed to the patronage of the local woolman, John Tame, and his son Edmund, the putative builder of **Rendcomb** church. Thus it counts as a Cotswold 'wool' church. Yet it is far too big and expensive to have been built by one family, even though the Tames were wealthy by local standards. John Tame certainly paid for the north chapel, now the Lady chapel: his will stipulated that he be buried there, and he was later joined by Edmund. The rest of the building, however, is far more likely to have been a joint effort by the parishioners of Fairford, a collective enterprise attested in numerous other places. Trade symbols appear on the tower, and there are structural indications that another building team took over once the north chapel was built.

Apart from the rather top-heavy tower, with its aggressive upper storey and battlements added later, the church has all the characteristics of a low, broad Perpendicular structure, with wide windows of uniform pattern, and a battlemented parapet, punctuated by insistent pinnacles, concealing the flattish roof. Inside, however, you become aware of height, since the clerestory is much taller than it seems from the outside. Owing to the almost complete coverage of stained glass, the interior is quite dimly lit. It is also remarkably plain: the arcades are widely spaced to give maximum emphasis to the aisle windows and there is an expanse of uninterrupted wall between the arcade and clerestory, interrupted only

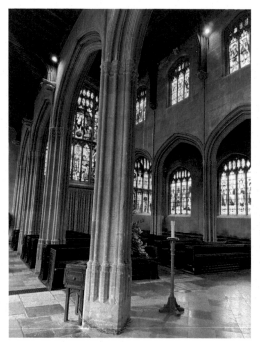

Above left: Interior looking north-west.

Above right: The tomb of John Tame.

by thin shafts rising to the corbels supporting the timber roof. The arch mouldings continue those of the piers, which are rhomboid with thin applied shafts rising to moulded capitals. Cotswold churches of this period, which seem so uniform, are in fact so individual in detail that formal comparisons are often hard to find, and the nearest parallel seems to be St Mary's University Church in Oxford, a connection that is otherwise unexplained but adds to the questions surrounding the building of the church.

John Tame's tomb, which also commemorates his wife, Alice, stands in the arch between the north chapel and the nave. It is a chest tomb with a fine memorial brass, and the armorial bearings of the Tame family, which appear also on the tower, there together with those of the aristocratic families that had formerly held the manor of Fairford. Look also for decorative architectural sculptures inside and out, and for the squat human oddities on the corners of the upper tower.

24. HAILES (DEDICATION UNKNOWN)

This is the parish church opposite the entrance to the ruins of the Cistercian abbey now managed by English Heritage. The abbey was founded in 1246 by Richard, Earl of Cornwall, the brother of King Henry III, and it housed a relic of the Holy Blood of Christ, an object of pilgrimage to the end of the Middle Ages. Neither the abbey nor the church should be missed. Although the abbey now lies in ruins, a window and arch in **Teddington** church may well have been brought from

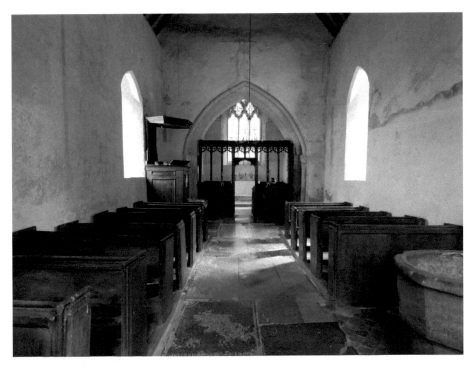

Interior looking east.

there after the Dissolution of the Monasteries: they give a good idea of its former architectural splendour.

Hailes church was founded in the mid-twelfth century by Ralph de Worcester, who had built a castle (now vanished). Only parts of the chancel arch survive from the Norman church, which seems to have been rebuilt during the thirteenth century. The nave and chancel, of the local golden limestone rubble, form two rectangles under steep tiled roofs, and you enter through the modern south porch. The pews may be medieval but the odd little belfry and the timber roofs inside are all later.

The interior consists of expanses of plain wall, which are liberally covered in wall paintings, especially in the chancel. The chancel arch was part of the rebuilding but the capitals, folded scallops, were retained; they show traces of paint. New windows were put into the chancel around 1310, and the paintings were done a little later. There is a form of diaper ornament with heraldry in lozenges on one side, and, on the other, alternating squares. These include lions, castles and the black eagle that was among the arms of Richard, Earl of Cornwall. The coupled monsters over the side windows are similar to those found in the margins of contemporary illuminated manuscripts, as are the figures of female saints in the blocked earlier windows.

In the nave the scenes are less well preserved but equally interesting, especially the hunting scene on the south wall, which may be a warning to Sabbath Breakers, as at **Ampney St Mary** in different form. The St Christopher and scene of *Weighing Souls* on the north wall are faded but easy to make out.

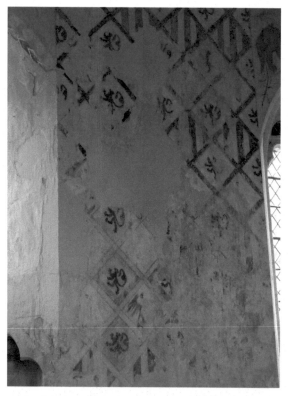

Left: Painted heraldry.

Below: Monstrous creatures.

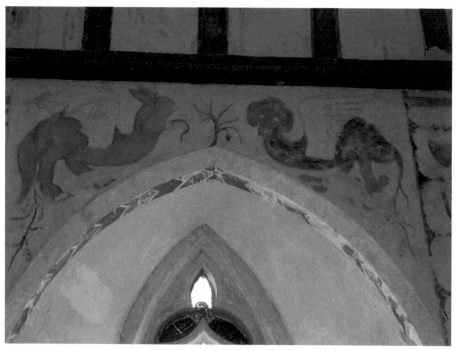

25. HARTPURY, ST MARY

Hartpury is not a nucleated village, and the church lies well south-west of the main part, in a most attractive group of buildings, one of which, a huge late medieval tithe barn immediately west of the church, must owe its existence to the fact that in the Middle Ages Hartpury belonged to St Peter's Abbey (now the cathedral) in Gloucester. Just south of the church is the former Roman Catholic chapel built in 1829 but restored and put to various non-religious uses during the twentieth century.

The church itself has also been restored, by the ubiquitous firm of Waller & Son, in the early 1880s, so it has a decidedly scraped appearance, with heavy use of

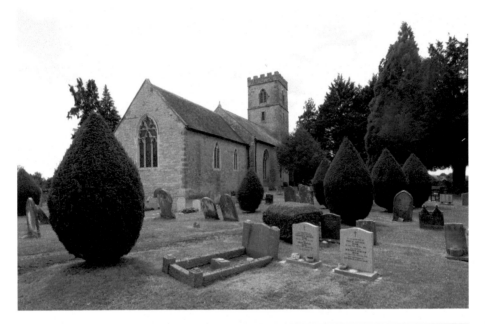

Above: The church from the north-east.

Right: Sculpture of *The Virgin and Child* by Patrick Conoley, 1990.

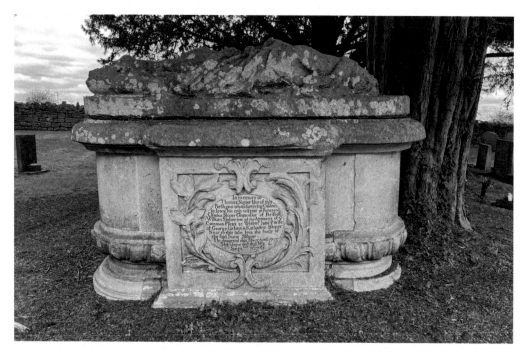

Tomb of Thomas Sloper (d. 1703).

mortar and stone laid bare. It is Norman in origin, with a plain chancel arch; but the chancel was added, or rebuilt, in the fourteenth century probably by the monastic owners. The tracery of its east window, with three daggers arranged in propeller form, the gaps filled by pointed triangles, has an exact match in the south nave aisle of Gloucester Cathedral. This looks like an assertion of identity. The sole truly medieval furnishing is the polygonal fifteenth-century font, pleasantly decorated in Perpendicular panelling. The lovely timber choir screen was designed in Norman Revival form in 1900. In the corner of the chancel is a small stone sculpture of the *Virgin and Child* made by Patrick Conoley in 1990 and given in his memory by his family. In the churchyard is the extraordinary chest tomb of Thomas Sloper (d. 1703) with a weathered effigy shrouded in drapery, a sort of medieval revival.

26. HIGHNAM, HOLY INNOCENTS

Holy Innocents is an estate church, like **Selsley**, with which it makes an interesting comparison. While the style of Selsley is Gothic Revival that just hints at the emerging Arts and Crafts style, Highnam, built around a decade before, in 1849–51, is full dress Gothic Revival in the spirit of the Oxford Movement and Augustus Pugin. Thomas Gambier Parry had bought the estate some twelve years earlier, and built the church partly as a memorial to his first wife. An artist, patron and collector, Gambier Parry brought in his old friend Henry Woodyer to design the structure and organise the fittings, but Gambier Parry himself was responsible for the richly decorated interior. Owing to his careful research into techniques of wall painting, he devised a recipe that could withstand the English climate, and

the painting did not need restoration until the 1980s. Its bright colours are now fully revived.

The church building is low, with aisles and chancel, and a western tower with a tall spire accurately derived from thirteenth-century examples. The window tracery is closer to the Decorated style of the fourteenth century, a period much favoured by Pugin, who was himself involved in the decoration of the chancel

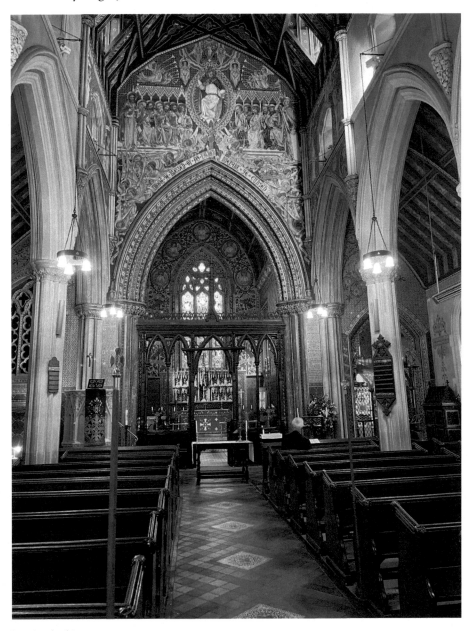

Interior looking east.

and some of the stained glass, but the arcade, with its clustered piers adorned by flat fillets, foliage on the capitals and corbels that support the roof, continue the late thirteenth-century theme, again accurately but without too much scholarly caution. The result is wonderfully lively. There is a clerestory and a wooden roof, again favoured by Pugin over stone vaults. The dormers in the last bay before the chancel were inserted shortly after completion, of the building to light Gambier Parry's great wall paintings: the *Last Judgement* over the chancel arch, with the *Expulsion of Adam and Eve* and *The Annunciation to the Virgin* on the side walls. Packed with figures, the bright colours imitate those of Italian late medieval fresco work, as does the technique of making the haloes in relief, here gilded plaster. In medieval thought Christ and the Virgin, as the 'new' Adam and Eve, redeemed mankind from the original sin of the Adam and Eve of the Old Testament. Gambier Parry also painted the scene of *Christ's Entry into Jerusalem* on the north aisle wall.

The brightness of these figured scenes is enhanced by the more subdued colours of the painted ornament that covers much of the wall surface and was probably carried out by assistants, especially in the chancel, with a mixture of foliage, geometric ornament and figured roundels. The latter were added by Gambier Parry to the simpler scheme put in by the distinguished firm of Crace and Co., who ornamented the chancel roof. This subtle palette also allows the stained glass to shine through without competition from the surrounding

 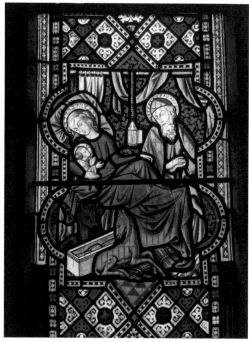

Above left: Capital of the north arcade with vault corbel above.

Above right: Window of *The Nativity* by A. W. N. Pugin and Hardman & Co.

walls, although Gambier Parry chose several different artists and was happy that they should pit their talents against each other. It is instructive to compare the solid, rather stiff figures in the north aisle windows made by the ubiquitous William Wailes, with the more elegant and relaxed style (closer to the fourteenth century) of those in the south aisle, which were designed by Pugin and made by Hardman and Co.

Hardman made the radiator grilles with an attention to detail matched by all the fittings, which have survived, some, like the pulpit, made in marble. Highnam is a complete example of a church that followed the principle of *Gesamtkunstwerk*, a total work of art encompassing both a building and its decoration, which was seen in the nineteenth century as a guiding principle of the Middle Ages but was achieved more often in medieval revival buildings such as this.

27. IRON ACTON, ST JAMES THE LESS

The church is associated with the Poyntz family, who were lords of the manor from the fourteenth century to the seventeenth, and the builders of Acton Court, the very interesting Tudor house nearby. St James the Less is built of Pennant stone, a sandstone local to South Wales and the Bristol area and quite different in texture and appearance from the limestones that dominate the Cotswold areas of the county. It is big and bold, boasting one of the great west towers of Gloucestershire, allegedly built by Robert Poyntz (d. 1439). Unfortunately the tomb slab in the church that gives this information is now invisible under carpeting. The tower has rather clumsily applied blind arcading and an extraordinary west door: the hood mould has two outward projecting cusps that seem to refer to the motif made famous in the fourteenth century by the Berkeley family at St Augustine's, Bristol (now the Cathedral).

As you go in, look at the upper left side of the inner door, where there is a small fragment of foliate relief carving that seems to be Anglo-Saxon. That is the only and last reference to the early Middle Ages since the building is fundamentally Perpendicular. The church interior is spacious, with a wide main vessel and south aisle, leading without transepts into the chancel and the former Poyntz chapel respectively. The south arcade has polygonal piers and moulded capitals, but the three arches between the chancel and the Poyntz chapel are four-centred with continuous mouldings, that is, they are uninterrupted by capitals so the pier runs smoothly into the arch. The nave clerestory is modest and rather tucked in. If you peer into the tower past the organ you can see part of the fan vault that was built into the tower, but all the rest of the church has wooden barrel ceilings, with some decoration.

The Poyntz chapel was no doubt grander in the past, and several memorials are now concealed (see above). Two effigies lie side by side next to the chancel, perhaps Sir John Poyntz (d. 1376), in armour, and a lady. Both are holding their hearts, which should indicate a heart burial, and both look decidedly archaic for the later fourteenth century. On the south wall is a Jacobean two-tier chest tomb, with an unidentified occupant. Note the seventeenth-century funerary helmet, spur and remains of a leather surcoat mounted high on the east wall: a type of chivalric funerary achievement going back to the Middle Ages. There is a distinct impression of some revivalism at work here.

Many of the fittings are the work of Sir T. G. Jackson, a flourishing architect of the Gothic Revival, who restored the church in 1880, when work was also done on the stained glass. The prominent altar reredos was made in 1929, by F. C. Eden. The handsome, prominent stone cross in the churchyard was made in the fifteenth century and is also attributed to Poyntz patronage.

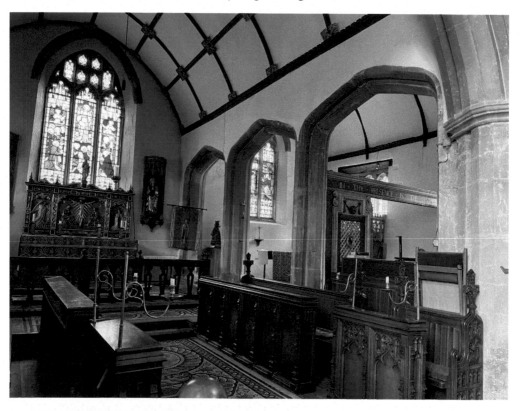

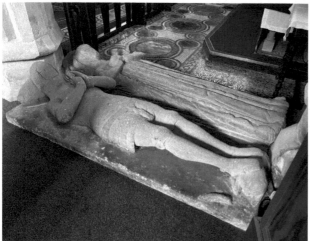

Above: View into the Poyntz chapel from the chancel.

Left: The effigies of Sir John Poyntz and a lady.

KEMPLEY

Kempley is in the north of the Forest of Dean, a scattered village with two exceptional churches. St Mary has one of the most complete cycles of twelfth-century wall paintings in Britain, and St Edward the Confessor is a fine representative of Arts and Crafts architecture.

28. ST MARY

This church is now in the care of English Heritage, which has recently conserved the paintings. Set in a large graveyard screened by trees and hedges, and entered through the porch on the far side of the building from the road, it guards its secrets well. The fourteenth-century wooden porch partly covers the Norman doorway, but note the original ironwork on the door. Inside, the rectangular chancel is divided from the rectangular nave by a magnificent arch with two orders: chevrons and chip carving, supported on capitals that are scalloped and scrolled. This fits the likely date that the church was built, towards the middle of the twelfth century, as do the original windows, those that are small and set into deep embrasures. The little east window has a roll moulding around it. Every surface was painted, including the arch and the window embrasures: those in the chancel form the twelfth-century programme, painted onto the barrel vault as well as the walls and windows.

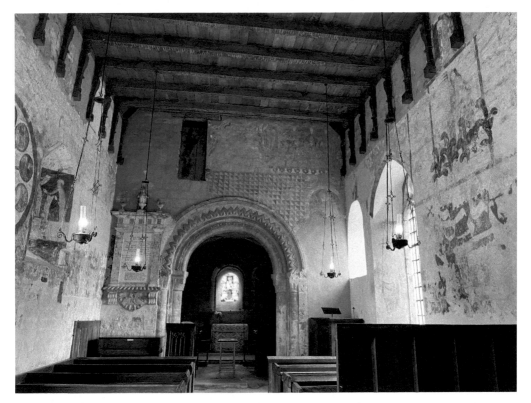

Interior looking east.

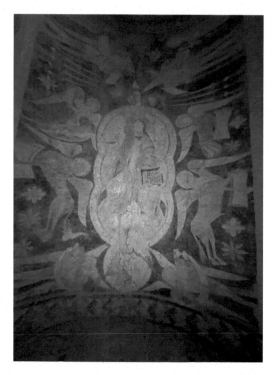

The chancel ceiling.

The chancel scheme is painted in red, ochre and white, all earth colours, but with some use of azurite, a precious blue mineral that has changed here to green. It depicts *Christ in Majesty* on the vault, with symbols of the *Evangelists*, sun, moon and stars, seraphim, the *Virgin Mary* and *St Peter*. On the walls are figures of the *Apostles*. This scheme is based on the book of Revelation in the New Testament, St John's Apocalyptic vision of the end of time. The architecture painted above the windows hints at the *New Jerusalem*, and it has parallels in rows of capitals on big cathedral doorways in France. Note in the embrasures the painted receding brickwork, a very early use of recession (unless it is a later modification). The nave programme is now of various medieval dates, but the recent conservators made an exciting discovery of a scene above the chancel arch on the south side that is contemporary with the chancel. It shows the Gospel story of the *Three Maries visiting Christ's tomb* after the Resurrection but before the Ascension, a scene that was enacted as part of the Easter liturgy. Since women were not allowed to take part, the roles were taken by monks. The scene strongly suggests that where the chancel is concerned with the world of Heaven, the nave, as appropriate, is about Christ on earth. The figures are not easy to make out, but the information sheets in the church give useful details and clearly illustrate the scene in close-up.

29. ST EDWARD THE CONFESSOR

Some distance from St Mary and near the village centre, this church is an excellent example of the rural Arts and Crafts style, designed by the young architect A. Randall Wells in 1902–3. Having worked as assistant to W. R. Lethaby, a

famous promoter of Arts and Crafts values, Wells brought a team of masons with him and built the church in pleasant pink-brown Forest of Dean stone. The patron, the Earl of Beauchamp, had already laid the foundations and made other stipulations, so Wells did not have an entirely free hand. Yet the result is visually satisfying and full of interest.

The building has long, low proportions, a main vessel and north aisle. The aisle is punctuated by the tower porch, which has a saddle roof with louvres below. The arch to the doorway is a four-sided polygon enclosing a three-sided one, an obvious reference to similar forms in the medieval work at Berkeley Castle and related buildings. The aisle has groups of small rectangular windows, and the church is essentially lit from the west, where a huge window opens up adorned with a lattice of tracery lozenges.

Above the north door is a relief carving of *Christ the Peacemaker*, designed and partly carved by Wells. It is set in a shallow-arched niche of contrasting grey stone. Christ, his hand raised in blessing and dressed in rather stiff drapery with folds of late medieval style but none of its relaxation, is set against a background

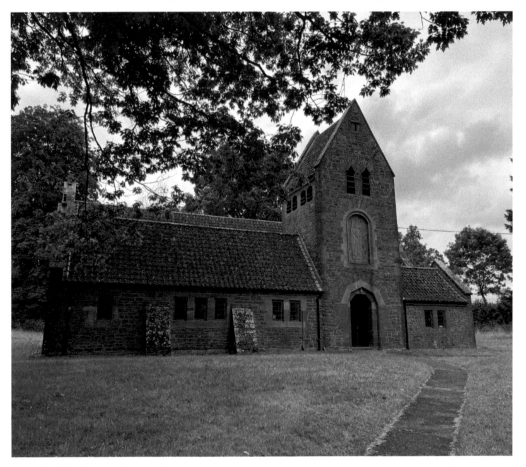

The church from the north.

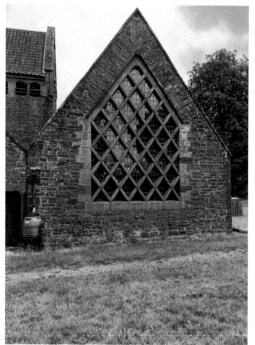 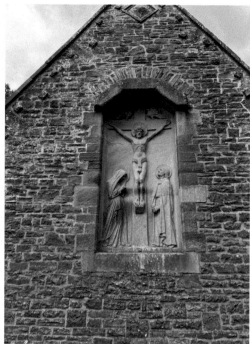

Above left: The west window.

Above right: Relief sculpture of *The Crucifixion* by Laurence Turner.

of stylized vine scrolls in shallow relief that ultimately owe their origin to the style of William Morris. On the east wall, in a deeper niche with a three-sided head, is a *Crucifixion* by Laurence Turner. The three figures are carved more conventionally with greater depth and plasticity, but they make their own quiet impact.

30. LECHLADE, ST LAWRENCE

The church stands back from the marketplace in the medieval town centre, so enclosed that if you approached from the north you would never imagine that the presence of the River Thames around 100 metres to the south: Lechlade is the river's highest navigable point. The building announces itself in this flat, riverine landscape by a tall, elegant spire atop the tower at the west end of the nave. The church was entirely rebuilt from the 1470s, starting with the nave and aisles, then the chancel and finally the north porch. The original driving force was Cecily, Duchess of York, mother of Kings Edward IV and Richard III, who founded two chantries in 1472 with the help of John Twyniho. Twyniho was a local lawyer, a close associate of John Tame of **Fairford** and stepson of William Prelatte, co-founder of the Trinity chapel in **Cirencester** church and a member of the household of Cecily's late husband, Richard, Duke of York. It is striking, however, that despite this mesh of close connections in the south-east corner of the county, the churches in these towns made prosperous by the wool trade have many differences in detail.

St Lawrence is built of limestone from the great quarry at Taynton, near Burford (Oxfordshire), which provided some of the best building stone in the country. The interior is light in both senses: the windows now having plain glass, it is well lit, and structurally it is also light, with four wide bays to the nave and aisles. The piers are rhomboid, with shafts at their cardinal points and minor shafts set in mouldings between. All seems to undulate but the shafts are bound at the top by strong moulded capitals leading to arches that show that the depth of the wall is greater than it seems. The bases are polygonal, moulded in two tiers typical of the late fifteenth century. The clerestory sits squarely above the arcade, with the wall posts of the timber roof rising between the windows. The large aisle windows have two reticulations, multi-cusped and showing that the ogee curve so beloved of the fourteenth century persisted right through the Perpendicular period.

The chancel is full of sculpture: timber bosses on the ceiling, repainted in modern times, mostly with angels holding instruments of Christ's Passion, for example the *Crown of Thorns* and the *Nails* driven through his hands and feet at the Crucifixion; and symbols of the four *Evangelists* supporting the roof, who although carved of stone are rather cosily reminiscent of soft toys. Elsewhere in the church, however, there is a small relief of *St Agatha*, which leaves you in no

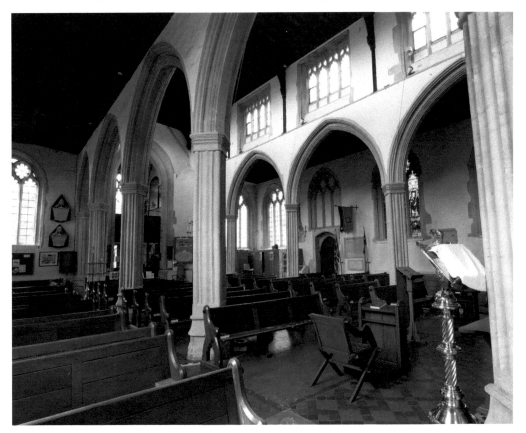

Interior looking north-west.

The sanctuary ceiling.

doubt of the manner of her martyrdom, and on the exterior, above the east wall of the chancel, stands a carved figure of *St Lawrence*, patron saint of the church, holding the grid iron on which he was grilled.

The north porch has some good corbel figures, but perhaps of greater interest is the vault, an uncusped star pattern, probably of the early sixteenth century and with stylistic associations with high-status buildings.

31. LONGBOROUGH, ST JAMES

This is a big church for a big village. The interior was over-restored in the 1880s, but the building is of great interest, having a south transept with superb flowing tracery of around 1340, and a north transept that was built in vaguely medieval style in 1822 as a burial chapel for the Cockerell family of nearby Sezincote, by their cousin, the distinguished architect C. R. Cockerell. The late nineteenth-century restoration seems to have involved moving the original Norman chancel arch, with scallop capitals, to the north wall of the chancel, framing the organ. The present chancel arch has hefty mouldings in fourteenth-century style. At the same time a set of sedilia, seats for the priests, was removed to an upper wall in the south transept.

The huge south transept window, best observed from the outside, is an intricate swirl of flowing, ogival forms, with simpler flowing tracery windows elsewhere in

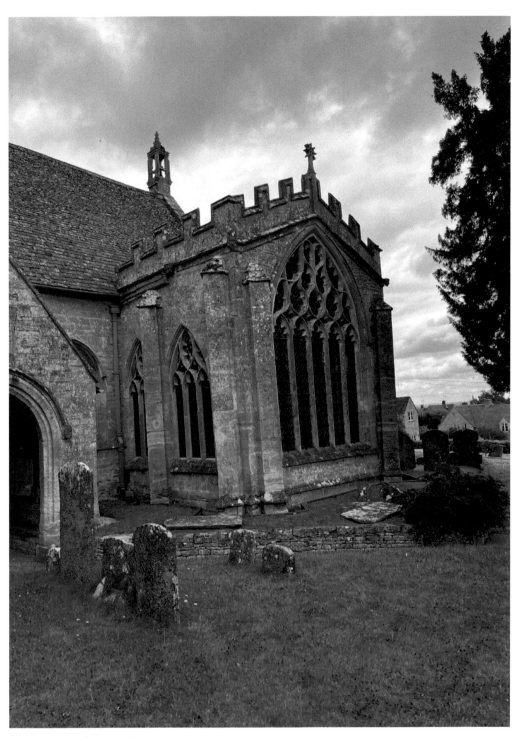

Exterior of the south transept.

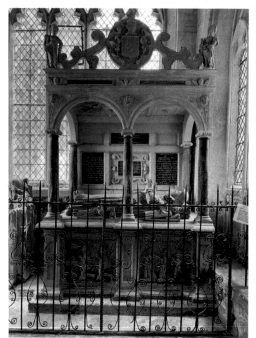
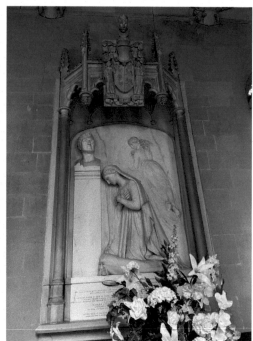

Above left: The tomb of Sir William and Lady Leigh.

Above right: Memorial to Sir Charles Cockerell by Sir Richard Westmacott.

the church. The church came into the possession of the abbots of **Hailes Abbey** in 1326, but the new chapel may be linked to the tomb of a knight that seems to be of similar date to the tracery, though it may have been moved into it from elsewhere. Next to it is the fine seventeenth-century tomb of Sir William and Lady Leigh, with their mourning children, living and dead. The Sezincote chapel, reached by an iron staircase, is dominated by the memorial to Sir Charles Cockerell (d. 1837) by Richard Westmacott: a marble bust and sorrowing female figure in relief, under a 'medieval' canopy. Westmacott's work is always worth seeking out, but do not ignore the splendid stained glass in this chapel.

32. MEYSEY HAMPTON, ST MARY

St Mary's is an impressive church, cruciform with a square central tower, decorated with a battlement parapet in the late Middle Ages. It is built of creamy-grey rubble with squared stones for corners, windows and doors. The thin lancet windows of the aisleless nave and transepts suggest an early thirteenth-century date, but the four arches of the crossing and the chancel are around a century later. The chancel has a contemporary set of liturgical furnishings including a tomb on the north side, probably that of the builder, who was likely the parish priest. On the south side are a piscina, sedilia and another tomb recess. These are decorated with the arch-and-gable motif, pinnacles and big seaweedy foliage along the gables, a beautiful example of Decorated architectural ornament. Although such ensembles

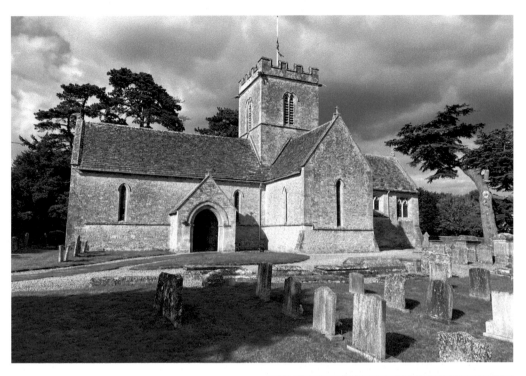

Above: The church from the south.

Right: Interior of the chancel.

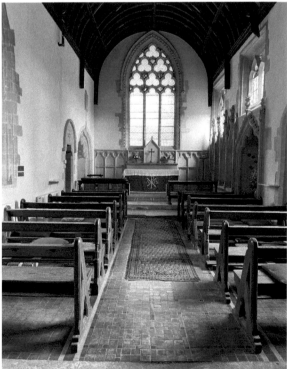

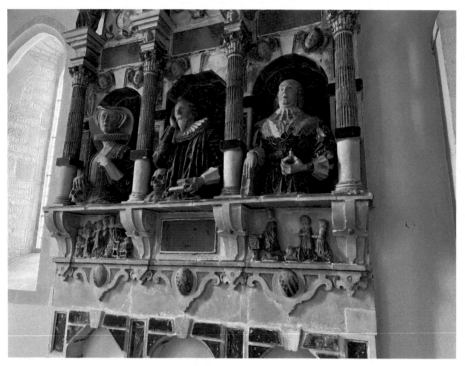

Memorial to Sir James Vaulx and his family.

are not rare in themselves, they are unusual survivals in Gloucestershire. In the south transept is the wonderful wall monument to Sir James Vaulx (d. 1626), conversing with his two wives and a row of children beneath. In the churchyard by the south transept is an eighteenth-century bale tomb, a type restricted mainly to the Cotswolds, with the semi-cylindrical capstone erroneously thought to resemble a woolsack. The font, a heavy Gothic Revival design, is the work of James Brooks, who restored the church in 1874.

33. NORTHLEACH, ST PETER AND ST PAUL

Northleach is the so-called 'wool church', rebuilt in the fifteenth century with contributions from local wool merchants. First among them is John Fortey (d. 1458), who bequeathed £300 specifically to complete the work he had begun.

The west tower, plain but for its ornate top level, rises three storeys above the church set confidently atop the sloping churchyard. The fourteenth-century chancel survived the reconstruction, complete with some fragmentary remains of its Anglo-Norman predecessor, but was brought up to date with new windows in fifteenth-century style. The later builders concentrated on the magnificent entrance porch and nave. On the screen front of the porch the display of statues – *The Virgin Mary*, the *Trinity* and two saints – is a rare example of what was once common, now represented in most churches by empty niches.

The lofty, light nave is dominated by huge windows at both levels, the clerestory filling each bay and continued across the east wall above the chancel arch, as in

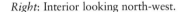

Above: John Fortey's merchant's mark, detail of his memorial brass, *c.* 1458.

Right: Interior looking north-west.

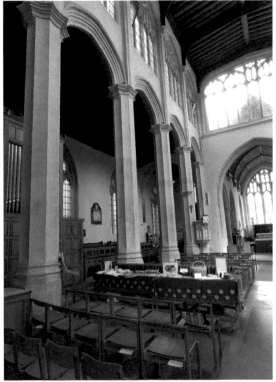

some other Cotswold churches, notably **Cirencester** and **Chipping Camden**, with which Northleach shares the elevation design: the five bays are separated by slim octagonal piers with marked concave sides, the concavities repeated in the moulded capitals. Above the multi-moulded arches flat strips of masonry frame the clerestory, deepening the wall into two planes, a feature that appears also at **Cirencester**. Amid the beautiful proportions and cool creamy stonework the timber roofs of the nave and aisles seem tactfully to draw little attention to themselves.

The font, which perhaps survives from the earlier nave, is decorated with musical angels, and the goblet-shaped pulpit is contemporary with the present building. The many memorial brasses set into the floor, showing the merchants and their wives, their sheep and their woolsacks, embody the social history of the day. John Fortey's brass, showing his merchant's mark, is under the north arcade of the nave.

34. OZLEWORTH, ST NICHOLAS

St Nicholas of Myra, the original Santa Claus, was an Early Christian saint whose bones were allegedly brought from Myra in southern Turkey to Bari in Italy in the late eleventh century. His fictional biography recounts many miracles which were frequently illustrated throughout the Middle Ages. Ozleworth church, which is dedicated to him, stands in the grounds of Ozleworth Park, but it is looked after by the Churches Conservation Trust and is fully accessible along well-marked paths, though the first hundred metres may be slippery after rain. The building

is solidly planted in its very attractive site overlooking one of the deep valleys down which the Cotswold hills dissolve into the Severn Vale. The exterior effect is pleasantly blocky and reminiscent of children's wooden building bricks, and the four-square quality is somehow enhanced by a polygonal interruption in the form of the hexagonal central tower, which is very unusual.

The first church was built probably before 1150, but what we see now are the modifications made some decades later. The tower sits between the single-cell nave and chancel, with a south doorway into the east end of the nave. While the tower might precede the present nave, its irregular sides, which exactly fit the joins with the nave and chancel, suggest otherwise. It has two light openings in the upper story and the roof is an irregular pyramid. The entrance door is richly decorated with blowsy foliage that belongs around 1200, when shallow, stylised Romanesque was yielding to more three-dimensional forms, and the foliage style with grouped stalks and leaves bending forwards like clenched fists, known as stiff-leaf, was just being developed. Here the leaf formations are arranged around a series of cusped and moulded half-arches.

There is more of this in later form in the arch into the tower, which is slightly pointed, probably for structural reasons, and is thick with a pattern of openwork chevrons, supported on half-shafts with fine, delicate foliage capitals that take stiff-leaf one stage further. The robust font certainly predates this, showing that the arch has to be a later change. The chancel was extended in the fourteenth century, with a simple ogival window in the east wall. Note the stairs to a former

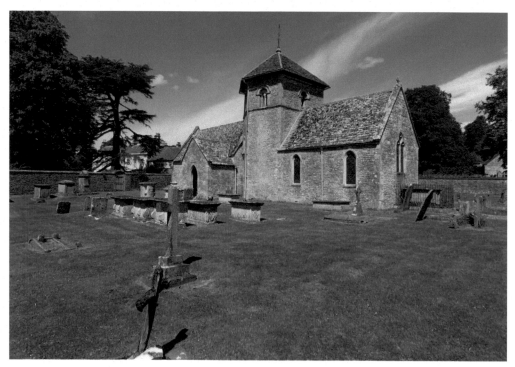

Church from the south-east.

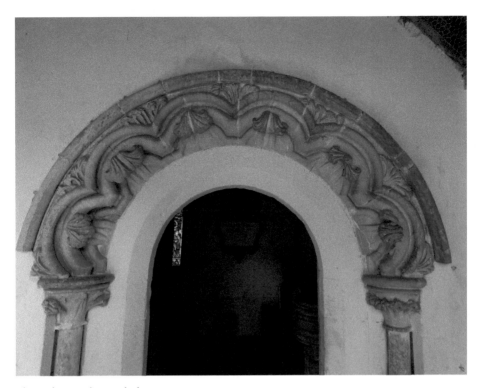

The arch over the south door.

rood screen that would have stretched across the arch from the tower into the chancel. The altar and the mosaic reredos are by the Revd Lowder, who restored the whole church in the 1870s. There are some good and elaborate tombs in the churchyard, and a particularly touching wall tablet to Catherine Clutterbuck (d. 1805) depicting a weeping willow over an urn, a motif similar to a tombstone in **Ruardean** churchyard.

35. PAINSWICK, ST MARY

A large church, conspicuous for its spire, in a huge and impressive churchyard in the middle of town. The church is a much-restored building of the fourteenth and fifteenth centuries, with widely spaced arcades and lit by big Perpendicular windows. Beyond the chancel arch the choir has arcades through to the aisles and an eastern arch leading into the small, aisleless sanctuary. The north chapel has a reredos made in mosaic tile or *opus sectile* in 1894 illustrating an appearance of Christ to the apostles after his Resurrection. On the north wall of the chapel is a real oddity: a tomb that began life in the fifteenth century as a Purbeck marble chest tomb was enhanced by a stone canopy in the sixteenth century when Sir William Kingston was buried there; and finally, in 1800, received from the chancel the kneeling effigies of Dr John Seaman (d. 1623) and his wife, facing each other across two carved books topped by a Composite column, which supports the canopy.

Oddities aside, the glory of Painswick is the churchyard. Its many yew trees, grouped and cut to cylindrical and cone shapes, stand guard over an array of fine chest tombs and headstones, many made in the eighteenth century when the town was at its most prosperous. The local limestone, used also for many houses in the town, is a creamy-grey that catches the light and is perfect for relief carving. The most distinctive tombs are the tall blocks topped by small domes, known for obvious reasons as tea caddies, which are not unique to Painswick but are more numerous here than elsewhere. The more usual chests are carved with wreaths, angels and heraldic supporters holding up fast-disappearing inscriptions, and several headstones illustrate the tools of a craftsman's trade. Near the lychgate is the prominent plain pyramid commemorating John Bryan (d. 1787), from one of the families of Painswick masons, who paid for various works in and around the church and is widely accredited with inventing the tea caddy tomb type, though there is no direct evidence to support this.

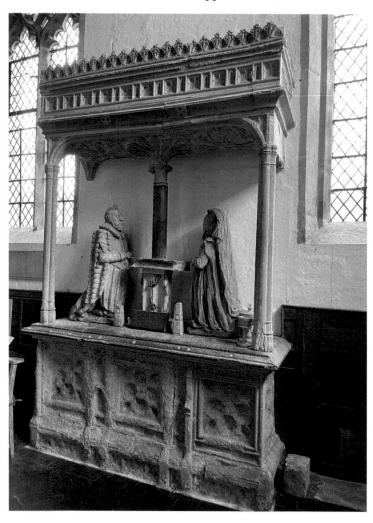

Tomb of Sir William and Lady Kingston.

Above: The churchyard
with tea caddy tombs.

Right: Tomb of John
Bryan.

36. QUENINGTON, ST SWITHIN

The main body of the church has been much restored and altered, but it is Norman in origin, as you can see from its plan, the nave and chancel both single-cell, and the odd surviving detail, such as windows and stringcourses in the chancel and a number of loose carved stones that have been set in the west end of the nave. The manor was held by the powerful de Lacy family, who may have built the church. Certainly it predates the arrival of the Knights Hospitaller, who founded a preceptory here in 1193 (their gatehouse and mill-race remain). What do survive from the twelfth century are the north and south doorways to the nave, spectacular pieces of Romanesque sculpture that display both a great range of decorative ornament and tympana with iconography quite extraordinary for a small parish church.

The designs of the doorways are different in conception, and although contemporary, they may be by different hands. The north door, now the entrance to the church, is surmounted by a sculpted and decayed sheep's head placed there in the fifteenth century. The arch has three orders and a hood moulding, separated from the jambs by oblong abacus blocks that break any continuity with the jambs. Inner jambs support the tympanum, which is not absorbed into the general composition. Two kinds of chevron dominate: one parallel to the facing plane and the other at right-angles to it. Shells and foliage occupy the outer orders of the arch, while the outer jambs have large square rosette motifs that adumbrate later

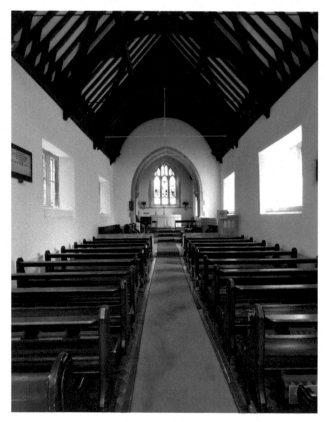

Interior looking east.

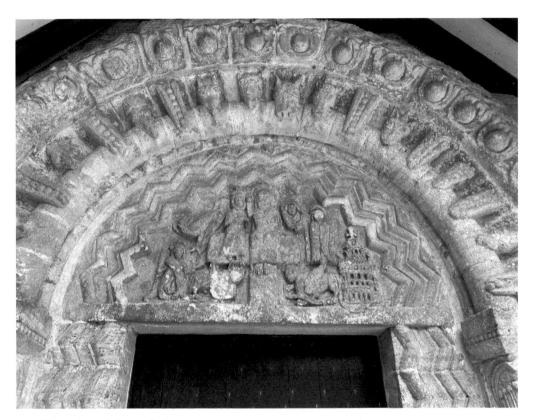

Tympanum of the south door.

diaper ornament. Foliage capitals top the nook shafts, backed by blocks above the middle order decorated with interlace and chip carving. The south door also has three orders, but here the inner order (of chevrons again) is continuous from the jambs round the tympanum, incorporating the latter into to composition as a whole. The middle order is a roll moulding interrupted by the thinnest of abaci and capitals, clasped all along by that other ubiquitous motif of mature English Romanesque: the beakhead. Heads of creatures with long beaks are interspersed with more stylised clasping motifs.

The tympana are carved in shallow relief. The north tympanum shows the *Harrowing of Hell*, a popular medieval subject based on hints in the Bible that after his Resurrection Christ descended to Hell to fight the forces of evil. Christ uses the long cross that symbolises the Resurrection to spear the humanoid Satan in the mouth, iconography comparable to St George killing the dragon, as at **Ruardean**. Little figures beg to be rescued, while the sun shining above them represents God the Father. The south tympanum is a more interesting and intriguing composition. It features Christ enthroned in Majesty with the Virgin Mary, surrounded by the symbols of the Evangelists, with in the corner a small building with many windows, topped by a cross, which must represent the Heavenly Jerusalem. The Virgin holds an object that has been interpreted as a dove. The speculation is that

this is a very early example in England of the great theme of the *Coronation of the Virgin*, which is otherwise known at this time on a capital from Reading Abbey. Here it is not clear that Christ is holding anything, let alone a crown, and the Virgin is not bending her head to receive one; but this may be the sculptor's first effort at unfamiliar iconography. The carving is unsophisticated. On the other hand, England's enthusiasm for the cult of the Virgin is traceable to Anglo-Saxon times, and the appearance at Quenington of a theme that was to be later developed so grandly on the doors of French cathedrals is entirely possible.

Among some interesting tombs in the churchyard is an eighteenth-century chest tomb with lyre-shaped ends and topped by the so-called 'bale motif', from the mistaken belief that it resembles a woolpack. Bale tombs are largely confined to the Cotswolds and were made in the seventeenth and eighteenth centuries.

37. RENDCOMB, ST PETER

The church stands next to the entrance to Rendcomb School, the former Rendcomb House, which dominates much of the village. In the north wall are the partly concealed remains of the piers belonging to its predecessor, which look late Norman, though the traces of pointed arches on the outside of the same wall indicate that this building dated to the very end of the twelfth century or the beginning of the thirteenth. Its replacement is very thoroughly Perpendicular. Traditionally it was built by Sir Edmund Tame (d. 1534), resident of Rendcomb and son of John Tame of **Fairford**. Although the east end of the south aisle was

The church from the south.

an apparent chantry chapel in which Edmund might have been buried, he chose burial in Fairford, in the chapel founded by his father.

There is a west tower but it has very little impact on the church's interior. The windows are wide, with four-centred arches, and, partly bereft of stained glass, allow a lot of light into the building. It is light both structurally and atmospherically. The arcade runs through to the east, making no distinction between nave and chancel: the liturgical divisions are marked by wooden screens. The arcade, the capitals and bases are sharply cut and the piers defined by concave mouldings reminiscent of **Northleach** and **Chipping Campden**. Stone corbels in angelic forms support the wooden roof.

Above: Angel corbels in the south aisle.

Right: The font.

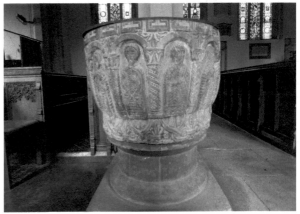

The glory of Rendcomb is its Romanesque font, which was brought from Elmore Court and used at Rendcomb as a garden feature until it was recognised and rescued. It is tub-shaped, ornamented top and bottom with a key pattern and foliage, with between them shallow relief carvings of the apostles under arcades. The columns are decorated with chevron and other ornament resembling decorative columns in manuscript illustrations; the apostles (all except Judas) are shown frontally, solemn and bearded, with incised patterns on their drapery, but each is carefully differentiated.

38. RUARDEAN, ST JOHN THE BAPTIST

Ruardean stands at the north-west edge of the Forest of Dean. The church, crowned by a beautifully proportioned tall, slim spire, otherwise looks rather grim and barnlike from the outside; but its entrance porch shelters one of the great Romanesque carved tympana of the so-called 'Herefordshire school of sculpture', and there are other very interesting pieces inside the building, as well as some beguiling tombstones and memorials in the huge churchyard that falls away down the escarpment.

The tympanum over the south door at Ruardean was made around the middle of the twelfth century. It represents *St George and the Dragon*. Carved in shallow relief to fit the semi-circular shape of the panel, the saint, mounted on horseback and with cloak flying, thrusts his lance firmly into the mouth of the dragon, a traditionally serpent-like creature with the large eyes and muzzle adapted from the beast heads that flanked earlier doors such as, for example, **St Mary's, Deerhurst**. The composition is almost identical to that at Brinsop in Herefordshire, and it shares certain stylistic characteristics (the ribbed pattern on the cloak, for instance) with a group of carvings on doors, capitals and fonts, centred on but not exclusive to Herefordshire, whose sculptors seem to have worked closely together.

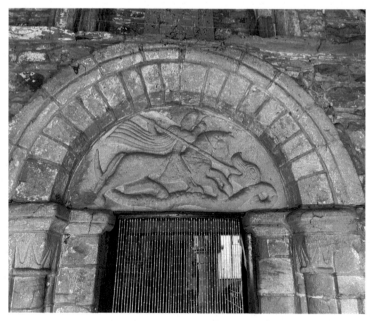

Tympanum of the south door.

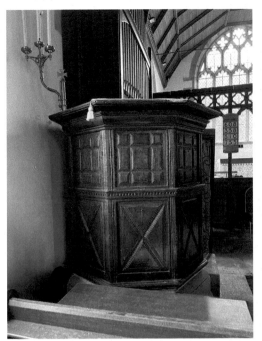

Above left: The pulpit.

Above right: Forest stone tomb slab in the churchyard.

A proposal, made many years ago, of an historical as well as a stylistic link is now generally accepted: the St George motif as shown here appears also at Parthenay-le-Vieux in western France, a church on one of the main pilgrimage routes to Santiago de Compostela. Oliver de Merlimond, the patron of Brinsop, who made such a pilgrimage, may have brought the motif back with him.

The tympanum at Ruardean is undoubtedly worth the journey, but the church contains other interesting and unusual objects. The font is not medieval or Victorian, but was made in 1657: standing on a high, stepped base, it is a plain white shallow octagon supported on a tapering octagonal stalk. As befits seventeenth-century religious sensibility, it is devoid of ornament of any kind, let alone sculptured figures. The wooden pulpit, adorned with two levels of carved panels, was made earlier in the same century. On the wall beside the font is a relief carving of the two fishes representing Pisces in the Zodiac. It is not in situ but was found in a nearby house, and is of high quality.

The churchyard has been rather tidied up and extended, but the view northwards from it over wooded hills is magnificent. The church also shows up well from this side: the tower and spire have undergone three rebuildings, the latest in 1866, when the spire was embellished with pinnacles and flying buttresses that make it look finely medieval. Arranged round the edge of the churchyard are a number of locally carved headstones, with pretty and heartfelt designs, bespeaking the long history of this Forest community.

39. SELSLEY, ALL SAINTS

We owe the existence of this small and perfectly formed Gothic Revival church to its patron, Sir Samuel Marling (d. 1883), who had recently acquired the estate and became a local philanthropist. Marling was free to do as he pleased, and his choice of architect in 1858 for the new church was George Frederick Bodley, who was only just beginning to make his name, as were the designers of the stained glass: the exceptionally talented trio of Pre-Raphaelite painters William Morris, Dante Gabriel Rossetti and Edward Burne-Jones. At Selsley we see Bodley and Morris in particular hinting at developments away from their youthful beginnings, Bodley from the academic Gothic in which he was trained, and Morris towards the Arts and Crafts movement with which he is so closely identified. Selsley makes an interesting comparison with the almost contemporary church at **Highnam**.

The church is set well below the road, standing at the bottom of its steep churchyard. It is a simple building with a short north aisle to the nave and a polygonal apse. The tall west tower, with its distinctive saddleback roof, is offset north of the main vessel. Sir Samuel Marling's tomb is placed on the outside wall of the chancel. The carving above is attributed to Joshua Wall, who was responsible for the interior sculptures. The nave and aisle are separated by a two-bay arcade, the double-chamfered arches supported on a stout central column of red granite with a limestone shaft ring halfway up. The splendid capital, cylindrical under a cruciform

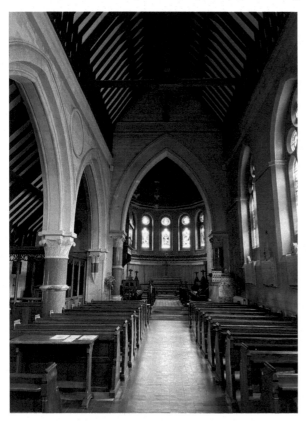

Interior looking east.

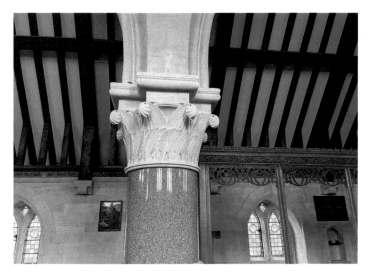

The arcade capital.

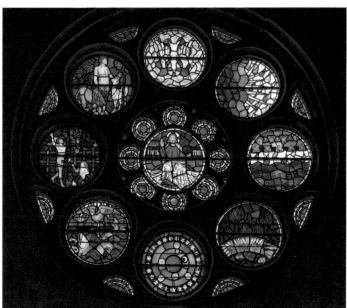

Creation window.
(Photo: Stephen
Goss)

abacus, is a creative version of early Gothic leaf forms below crockets: stylised leaves bending forward on long stalks. These forms appear also on the capitals of the chancel arch, and together with the plate tracery in the windows they show that the idea behind the design of the building was drawn from the very first phase of medieval Gothic, seen in northern France from the second half of the twelfth century.

The stained glass is not far removed in spirit from the same era, essentially using drapery styles common at that time. The scheme was devised by Philip Webb and the individual scenes designed by Morris, Rossetti and Burne-Jones, whose different styles repay study. The great *Creation* window, the western rose, was

designed by Burne-Jones, with individual roundels made by Burne-Jones himself, William Morris and Philip Webb. It depicts the story of the Creation of the world as told in the Old Testament book of Genesis, in roundels of jewel-like glass of such colour and abstraction that they could be mistaken for quite recent designs. Yet in this window and in Morris's *Annunciation* scene in the chancel notice the use of background trellis that recalls the famous fabric pattern that he co-designed with Webb and is still current today. Burne-Jones's drapery styles have more sway and movement than Morris's more stolid figures, while Rossetti's windows are strong on narrative but fussier in style.

The font is strong, simple and made of grey stone from the Forest of Dean. All the liturgical furnishings, including the elaborate pulpit, are Bodley's, but the screen round the Marling Memorial chapel in the aisle was made in 1937 by A. Linton Iredale. Delicate and pretty, it complements its formidable surroundings without in any way competing with them.

40. SLIMBRIDGE, ST JOHN

Slimbridge, in the Vale of Berkeley bordering the upper reaches of the Severn Estuary, is famous for its Wildfowl and Wetlands Trust, home to thousands of migrating birds and a magnet for human visitors. The tall tower and spire of the church are visible for miles in this flat landscape, the church itself worth a visit even without the attractions beyond the village.

It has the usual appearance of a late-ish medieval parish church, until you go inside and are confronted by the nave arcades with their abundant foliage capitals, stylistically on the turn from late Romanesque trumpet scallops to the succeeding stiff-leaf, clutches of bunched, stylised leaves like clenched fists, supported on stalks carved in very shallow relief. No single capital is the same, yet the effect is calm, rich and consistent. Some have small bunches of berries poking through the leaves, reminiscent of the capitals at Wells Cathedral. The foliage rises straight from the pier without the usual ring, characteristic of a group of late twelfth- and early

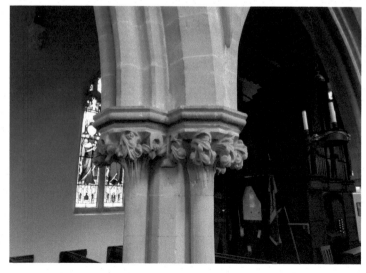

Stiffleaf capital in the nave.

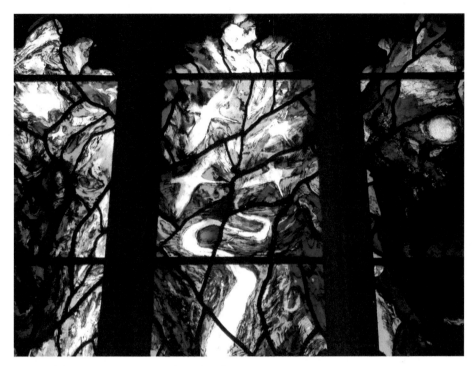

Detail of the Peter Scott memorial window by Tom Denny, 1994.

thirteenth-century churches in the South West, including Wells. The clerestory was added in the nineteenth century and you can see the original roofline on the west wall. The fourteenth-century Decorated work in the chancel and windows is good of its kind, but the nave is why you are there. Do not miss the two western windows in the south aisle. The coloured one was made by Tom Denny in 1994 to commemorate Sir Peter Scott (d. 1989), founder of the Trust: white swans fly among blues and greens. The plain glass window next to it was engraved by Rory Young (d. 2023).

41. STROUD, CONGREGATIONAL CHAPEL

Known to its members as Bedford Street Chapel to distinguish it from its predecessor, the Old Chapel in Chapel Street, the church was designed and built from 1835 to 1837 by Charles Baker. Baker was a local man, from Painswick, known primarily as a surveyor and road engineer; but in the nineteenth century builders were less narrowly specialist than they are now, and surveyors and engineers regularly designed handsome buildings in classical styles.

This chapel is Greek Revival on the outside, an oblong building faced in limestone, with a stair turret on the corner. The chapel itself is, uniquely, on the first floor, supported on cast-iron columns made in Gloucester, which survive in the altered ground floor. The arrangement is reflected on the main front in the round-headed first-floor window flanked by tall Ionic columns with a triangular pediment above. The original entrance was in the stout circular turret on the corner, a big landmark as you approach. Its ground storey has quasi-rustication; the upper is

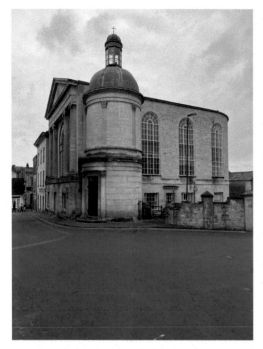

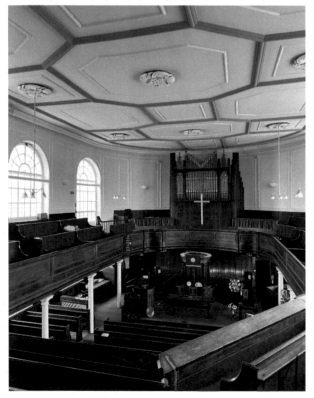

Above left: Exterior with the stair turret.

Above right: The staircase seen from above.

Left: The interior from the gallery.

plain, with spaced Corinthian pilasters, and the turret is topped by a dome with a tall lantern. Inside, a magnificent spiral staircase rises the full height of the turret. From below you can see that the base of the dome is not quite circular, possibly a simple miscalculation by Baker of how to relate the staircase to the dome.

The chapel interior is lit by huge round-headed sash windows, now slightly obscured by side galleries that were added to the original west gallery in 1851. The main floor is filled with pews, and the fittings are all in polished oak and pine, dominated by the pulpit. It is cylindrical and elevated, reached by its own staircase, and fronted by Corinthian columns. Alteration to the building has been minimal and such restoration as has been necessary is unobtrusive and sympathetic.

42. TEDDINGTON, ST NICHOLAS

A charming village church with a curious building history, wrapped around its earliest features, the narrow, plain Norman chancel arch and the fragments of chip-carving and other architectural ornament that have been inserted into the wall. Otherwise it seems to have been expanded in the thirteenth century and new, Decorated windows put in around the 1330s, together with a new base for the font, which has small columns decorated with ballflower. Then, after the Reformation, it received much attention: in 1567 the west tower was built, in Perpendicular style but a little thin proportionally; and the nave windows were renewed in the seventeenth century. The furnishings – communion rails, pulpit,

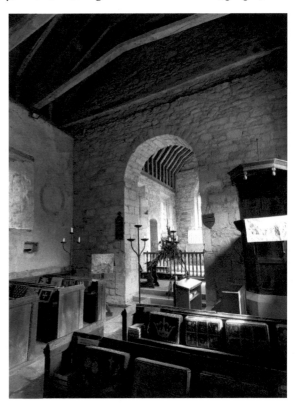

The chancel arch.

The tower arch and west window.

reading desk and pews – all date to the seventeenth century; the pulpit has the date 1655. The restoration of 1898 left the chancel walls exposed, with thick mortar layers, giving it a rather raw look; but plaster was left on the nave walls, retaining the huge coat of arms of William and Mary, painted in 1689 within a year of the beginning of their joint reign.

The mystery is the work in the tower: a west window with a cusped oculus and an elaborate arch into the nave, which is supported on piers that are much too big for their position. The arch had to be inserted into the existing west wall, but the poor fit of the piers suggests that it was brought from elsewhere. The speculation is that both arch and window were brought from nearby **Hailes Abbey**, since the work in both places is identical, and the monastery at Hailes had been dissolved around thirty years before and was thus a good source of well-carved stone.

43. TETBURY, ST MARY

St Mary's stands on the edge of a steep hill, the approach to it dominated by the impressive west tower and spire, which give the impression that this is a medieval church. So it once was, but the body of the building is an eighteenth-century replacement of its dilapidated thirteenth-century predecessor, and even the tower and spire, the only surviving parts of the original building, were replicated in the 1890s by Waller & Son, whose restoration work is seen all over the county.

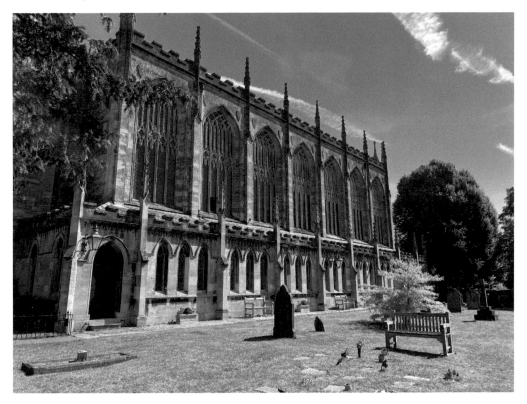

The church from the south.

Interior looking west.

Francis Hiorne of Warwick built the present church in the late 1770s, in the delightful kind of Gothic style that made capricious use of Gothic forms as well as devices that you would never see in a medieval church. The most obvious of these is the plan, which flanks a conventional interior of nave and aisles with low, single-storey passages down each side, opening into the main vessel at each bay. The nave dominates all: the chancel is one bay deep, as befitted contemporary suspicion of Popish attitudes, so the building is a vast preaching space, filled with the original pews. The west gallery is extended some distance on each side of the nave.

The exterior is of stone with artificial Coade stone for the window traceries; but the interior is made of wood for the piers and plaster for the vault, a conceit that would have appealed to the medieval mind, which enjoyed artifice though not on such a monumental scale. Everything is exaggerated. Hiorne chose to build a hall church, that is with nave and aisles of equal height, a form that was very popular for the late medieval churches of Germany, but here everything is stretched like elastic. Hall churches are lit entirely by the aisle windows, and at Tetbury they are exceptionally tall, raising the question of which came first: the desire for enormous windows or the desire for a very high interior, which the windows then had to match. The thin, clustered piers rise almost to infinity, but their profile is medieval enough, as is the sexpartite ribbing of the vault. The window tracery, too, is soundly based on Perpendicular precedents, as are the buttresses and battlements of the exterior.

There are some good tombs in the churchyard, and many wall tablets inside the church were evidently preserved from the earlier building since they predate this one.

44. TEWKESBURY ABBEY CHURCH OF ST MARY

Tewkesbury lies at the confluence of the rivers Avon and Severn and is liable to flooding. Whenever the waters engulf the town Tewkesbury abbey church appears in pictures standing peacefully unharmed above the surrounding floods. Medieval builders knew exactly what they were doing: many churches, some appearing in this book, were sited at the highest point of their parish settlement. Tewkesbury is by far the largest church to have been chosen here, much bigger than an ordinary parish church, even **Cirencester**, which claims its place as the largest purpose-built parish church in the county. Tewkesbury was a Benedictine abbey church; but its nave was for parochial use and in the 1540s, after the monastery had been dissolved, the townspeople bought the monks' area of the church east of the nave and made the whole building into the imposing parish church we see today.

It also benefited from centuries of wealthy patronage. Founded *c.* 1087 by the Norman Robert FitzHamon, the abbey passed into the possession of the powerful Clare family, who were significant landholders in the Marches of Wales. In the fourteenth century the abbey was transferred through marriage to the Despensers, friends and allies of King Edward II. During the fifteenth-century Wars of the Roses, after the battle of Tewkesbury in 1471 (still commemorated annually in the town) the Yorkist George, Duke of Clarence, was granted patronage and was buried there

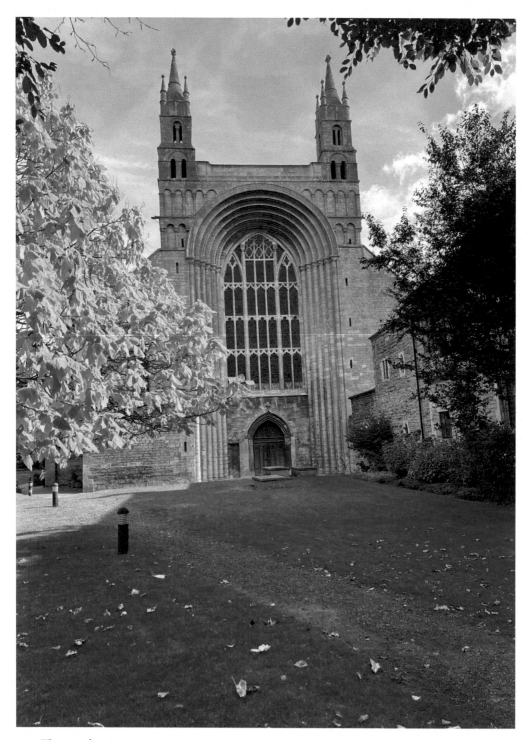

The west front.

in 1477. (George's interests also make an appearance at Cirencester and **Lechlade.**)
The architecture and decoration reflect these years of patronage: the Norman nave
and transepts were the work of FitzHamon and his heirs; surviving thirteenth-
century fragments are what is left of building by the Clares; and the Despensers
remodelled the choir and began the installation of the beautiful funerary monuments
that surround it. Both the architecture and adornments are of the highest quality,
as befits the abbey's wealth and status, the patrons apparently sharing the monks'
enthusiasm for continuously embellishing their church.

The building announces itself with a massive, square central crossing tower,
with round-headed Norman windows and intersecting applied arcading. The west
front was later modified by an enormous Perpendicular window, but it is one of
the few surviving monumental west fronts in this country. It is in the form of
an arch rising the full height of the building and topped by two small turrets. It
can be interpreted as a deliberate evocation of a Roman triumphal arch: not of
the ancient city but the city of Emperor Constantine, who in the fourth century
declared Christianity the official religion of the Empire, and which was regarded
in the Middle Ages as the centre of the Western church. Placed here, the arch
acts as a gateway to promised redemption and the New Jerusalem of the Bible.
The west door was used only for processions: the usual entry to the nave is by
the north porch and from there you should move at once to the central aisle to
appreciate the eight bays of tall columnar piers marching away towards the choir,

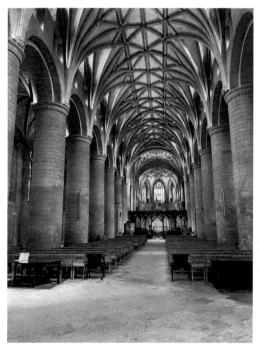
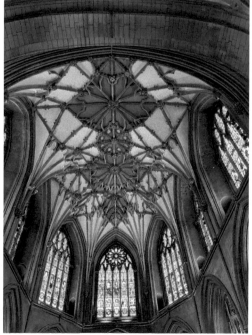

Above left: Interior looking east.

Above right: The choir vault.

with moulded capitals, plain arches and the tiny clerestory and arched passage above the arcade. The view eastwards is now open, but before the dissolution of the abbey the monks' part of the church, the choir and last two bays of the nave, was screened off, with lay access strictly controlled.

The original elevation of the transepts was different: remnants survive of wall pilasters rising through two storeys as the so-called 'Giant Order'. Big arches open to superimposed chapels, with a very early rib vault in the lower south-east chapel and above them a low, blind wall-passage. There is evidence that the transepts were vaulted with stone barrel vaults, so it is likely there was no clerestory there. Consensus has not been reached on this, nor on how the choir may have been treated, since in the fourteenth century its upper storeys were cut down to create the choir we have today.

From floor to ceiling the choir is a consistently planned work of art. The reason seems to have been the change of patronage by inheritance in 1314 from the Clare family to the Despensers, and the desire, whether theirs or prompted by the monks, to establish an elaborate family mausoleum in the latest style. The Anglo-Norman east chapels were abolished in favour of an ambulatory and radiating chapels (of which the central, projecting Lady chapel has been destroyed), and the upper storeys of the main elevation were reduced to two, with huge traceried

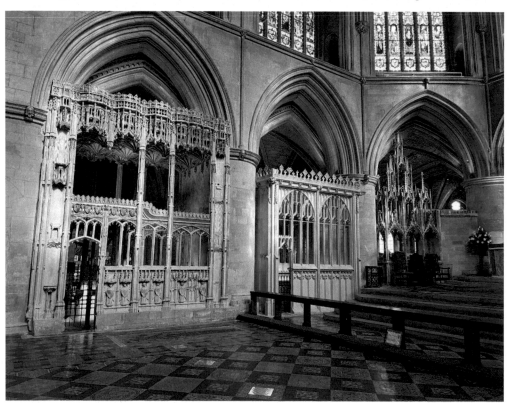

The cage chantries in the choir.

windows and an open passage. Over this they built an intricate vault that unites the space under a flower-like canopy, quite denying the relation of the vault to the bays beneath and creating a Paradise within which the Despensers were entombed between the columns and under the stained-glass windows, which depict judgement and Despenser family connections, as befits contemporary concerns with family and saving the soul. The tombs are the so-called 'cage chantries', miniature chapels in Perpendicular style complete with effigy, altar and, in some, fugitive paintings. Note the figure of Lord Despenser (d. 1375) kneeling in prayer under a tabernacle atop his tomb on the south side, and on the north the decorative fan vault in the Warwick chapel, built *c.* 1430. A cage chantry devoted to the abbey's founder, FitzHamon, embodies the monks' sense of tradition and history, placing the Despensers in a long line of benefactors.

The elaborate nave vault was put in a little before the choir vault. It is another excellent example of late medieval vaulting, with three strong longitudinal ridges and cross-ribs known as a net vault, yet its decorative quality does not clash with the monumental main elevation of the nave. The vault has many sculptured bosses where the ribs meet, repainted *c.* 1880 by Thomas Gambier Parry of **Highnam,** and both here and for the stained glass binoculars are useful.

In the abbey shop and outside the north transept are the remains of a two-storey chapel built probably in the 1210s, with good, if weathered, stiff-leaf foliage and finely cut mouldings with shaft rings and openwork chevron. This was erected under Clare patronage, and had it survived would have been an outstanding example of its period. On the south side of the nave are surviving wall mouldings from the abbey cloister, with the traditional door into the south-east bay of the nave: the traces of Perpendicular panelling suggest that the cloister was rebuilt in the fifteenth century.

ACKNOWLEDGEMENTS

My debt, and that of all visitors, to the clergy and staff of our churches for keeping their buildings open and so well looked after is infinite. I am particularly grateful to those who gave up their precious time to unlock churches that are not always open, and welcomed me with information, discussion, leaflets and coffee. I also thank Dr Stephen Goss, a peerless photographer of stained glass, who made a special journey to record the windows at Selsley. My grateful thanks to the publications team at Amberley Publishing.